PETE TURNER

PHOTOGRAPHS

INTRODUCTION BY OWEN EDWARDS

HARRY N. ABRAMS, INC., PUBLISHERS, NEW YORK

PETE TURNER PHOTOGRAPHS

To my teacher, Ralph Hattersley; my mentor, Harold T. P. Hayes;
and to my family, Reine and Alex Turner

Editor: Robert Morton
Designer: Samuel N. Antupit

Library of Congress Cataloging-in-Publication Data

Turner, Pete, 1934—
 Pete Turner photographs.

 Bibliography: p. 143
 1. Photography, Artistic. 2. Turner, Pete, 1934—
I. Edwards, Owen. II. Title.
TR654.T88 1986 770′.92′4 86–10793
ISBN 0–8109–1691–6

Published in 1987 by Harry N. Abrams, Incorporated, New York
All rights reserved. No part of the contents of this book may
be reproduced without the written permission of the publishers

Times Mirror Books

Printed and bound in Japan

CONTENTS

INTRODUCTION

In 1959 a young photographer named Pete Turner, not quite a nobody, but not at all a somebody either, with little more to recommend him than a fine arts degree, a head full of chemistry-set alchemy, a handful of published pictures, and no appointments for the next year or so, fell into some lucky connections and took a trip. Through the ever-imponderable workings of fate, Turner was hired to serve as the expedition photographer for an unlikely, alliterative trip from Capetown to Cairo organized by an American manufacturer, the Airstream Trailer Company.

Not counting his indentured service as an Army draftee, Turner's assignment to record the African adventures of forty-three sleekly plump, silvery Airstreams was his first real paying job as a photographer. For the trek, which would take more than six months, the company built a camper for the photographer that held enough fuel and water to take him fifteen hundred miles without having to figure out any of the local currencies. A special hiding place for film in a cool spot by the water tank even allowed him to travel through ten countries without having his pictures confiscated by dyspeptic border guards.

A century or so ago picture-taking adventurers like Frances Frith and Felix Beato headed for Cairo in dark-draped wagons to record ancient wonders and then sweat away hours developing glass plate negatives. Young Pete Turner had modernity on his side, but his sense of adventure and astonishment were pure nineteenth century. He had wanted to be a photographer, he knew the formulas and cabalistic measurements of the craft, and now, mile after mile, roll after roll, he was making photographs. "I just liked to shoot," Turner recalls. "I was so happy." From Southern Rhodesia to Northern, to Kenya, Uganda, Tanganyika, and on northward toward the Nile, a vast landscape and all it contained unfolded for Turner to photograph. And there was nothing but time to stalk and capture it all. Bliss.

In 1985 a photographer in his early fifties named Pete Turner, with a glittering reputation, a famous, formidable eye, and high-priced advertising assignments stretching toward infinity, was approached by a big-budget client and went on a trip. This venture was a commando raid compared to the massed troop movement of Airstreams. It lasted only a month, never left the continental United States, and involved many fewer people. But this time Turner was no mere adjunct, someone along for the ride to produce a public relations photo album. This time Turner was the reason for the trip, and the other travelers, though fewer, were all there under his orders. He wasn't provisioned for a leisurely sojourn, and he certainly didn't have time to spare. Instead, he had thirty days to produce six images for R. J. Reynolds; high action, breathlessly blurred shots of such cutting-edge sports as powerboat racing, dirt biking, and world-class downhill skiing. The point was to sell cigarettes.

To help him, Turner had a Lama turbine helicopter with a bravura pilot and its own full-time mechanic and fuel truck, plus a fully equipped mobile home to make life livable on location. At each location a hotel suite was set aside just for editing the day's take. In another room an accountant spent hours keeping track of the team's complex working budgets. Assistants went on ahead, like advance men for a presidential candidate, to scout locations and make sure the men and women to be photographed were where they were supposed to be and had the requisite equipment—100 mph-plus, bright red outboard motors, or Baja race cars straight out of *Road Warrior.*

Day after day Turner climbed aboard the helicopter to skitter dangerously close to the surface of California lakes, or rush down forty-five-degree Colorado slopes a few feet off the snow and scant yards ahead of a hunched skier only occasionally on the ground himself; hairy stuff, all to pursue the visual excitement that an advertiser felt necessary to capture the hearts and whim-

sical tastes of Americans. For Pete Turner it was a chance to keep shooting and—within reason, given a hundred constraints and more—to keep a toehold in that once-upon-a-time bliss.

On the wide and varied terrain of the twenty-six years that separate these two trips lies one of the most extraordinary careers in the history of photography. It is a career that is some part commerce and some part art, and like many careers that represent these two attracted opposites, it may be said to represent many counterbalanced things: the loss of freedom and the gain of fame; the metamorphosis from visionary nobody to celebrity seer and—no less important—to the artistic self as profit center; and the increasingly intense struggle to maintain originality and renewal against the tide of thousands and thousands of pictures made—the struggle not to lose Pete Turner the astonished traveler amid the complications in the life of Pete Turner renowned photographer, or, for that matter, to let Turner the dreamer end up imitating Turner the star, when such an imitation, done half well, is good enough to ensure commercial success.

At the beginning of a career, of course, the problem is not to resist imitating yourself, but simply to know what self you are in the first place. Among the classic ways a photographer goes about tracking down this elusive self is to load an old Ford Falcon (or some other such unprepossessing transport) with a couple of cameras and all the film he can afford—usually not much—and hit the road. Traditionally, poverty ensues, along with a desperate search for grants, mentors, an associate professor's slot at some undemanding but honorable college, and a thin volume of "images" printed by a well-meaning, marginal publisher. Sometimes the selves found along this inclined plane up the

steep slope of art are worth finding, and sometimes not. The trip is usually so confusing that it's hard to know.

Pete Turner, happily for himself, for photography, and for us, chose not to go this route. Instead, he determined from the beginning that he would make a living by working at making pictures, in color (highly unfashionable in art circles at the time), for money (an unspeakable act in those same circles). Turner's idea was more naive than contrary: there wasn't really any cosmic difference, he figured, between somebody who worked on a grant from a corporation or took an assignment from the same corporation, except that the one on assignment wouldn't have to pay for his pictures. Color pictures were particularly expensive to make, and Turner figured that the more pictures he could take, the more he would learn.

Having made that decision, Turner solved one essential problem—the necessity of feeding the artist—and gave himself another, the conundrum of keeping the artist alive and well in the midst of a thriving business.

One way to do this, probably the best way of all, is simply to merge art and commerce seamlessly—to create your art for those with the good sense to use it to sell trailers, or cigarettes, or magazines. Though not without its perils (Faustian bargains not the least of them), sometimes this blissful marriage of personal vision and profit works out with a minimum of compromises. Pete Turner's vision has been so singular that many buyers have been delighted to employ his way of seeing without any alteration.

But not all clients—whether editors, art directors, or account executives— are content to keep sending money without wanting to buy control with it. Doing just what you want and waiting for the buyers to line up can be a sometime thing, so no matter how brilliantly individual you may be, continuing to thrive as an

advertising and editorial photographer often means knowing how to do almost everything. Turner, having determined to succeed, to act as his own private foundation for the furtherance of his own art, became versatile with a vengeance. It is hard to conjure a picture that might be beyond his capacity to produce.

Yet for Turner, success at doing everything while doing it often and well is a mixed blessing. It's hard to think and work at the same time—or at least to think about anything more than the job at hand. Not for the working stiff those long, meditative stretches of desert through which the grant-seeking loner in the Ford Falcon passes on the way from one impeccable landscape to the next. Given enough of an interlude during which nothing but sagebrush and the odd billboard flash by the window, ideas are almost bound to come into the mind. Some might even be good ideas, at least good enough to provide propulsion for the next set of pictures.

For the photographers with neither the considered pace of genteel poverty nor the consideration of a Guggenheim Fellowship, such long thoughtful voids are implausible luxuries. Thinking about what's next must be done while doing what's now. New sources of energy have to be discovered literally on the wing, aloft in some infertile widebody hissing along at 30,000 feet from one job to the next.

Or, failing that, you can make work work for you. Isamu Noguchi once explained his creative methodology by saying that he figures out what he's going to do by doing it, and Pete Turner has come up with a similar tactic. He figures out what he's going to do by taking the photographs he's being paid to take, while at the same time making pictures that define and redefine what kind of photographer he is. Sometimes they are the same pictures, sometimes what seem private go public, and occasionally vice versa.

On his first big job with the Airstream armada, Turner fell into a pattern that has served him well ever since. The official pictures he made on that odd, epic journey survive in the company's literature, and they are perfectly serviceable. After all, Turner had a considerable formal education in the classic warp of photography. But, for the most part, they were not what we now so clearly recognize as "Turners." Then, late one afternoon at a railroad station in the Sudan, he made a certain picture, *Rolling Ball* (p.100); a peculiar juxtaposition of the setting sun and the odd, double triangular shape of the station roof, it is immeasurably far from the classic isn't-it-romantic travel picture. *Rolling Ball* is the kind of photograph someone might just make if he were in the right place at the right time and were a careful observer of the work of Pete Turner. The fact that the work of Pete Turner did not yet really exist makes *Rolling Ball* that most marvelous and inexplicable phenomenon—the big bang that creates an artist's universe.

Art history, photography division, is a cloudy and imprecise business. Those who work the turf no doubt long for epiphanies, for exact and unquestionable moments when artist A meets muse B and lives creatively ever after. Alas, the process is usually murkier than that, for ways of seeing and working are often constructed from bits and pieces of enlightenment. Pete Turner is the rare exception, a visionary sui generis, the thesis writer's dream; when he came back from his first big job he had become Pete Turner, with a way of seeing extraordinarily intact, and he has spent the years since simply becoming more so.

Rolling Ball was nothing at all like what other photographers were doing, though many of Turner's contemporaries—some of the best were his college classmates Jerry Uelsmann and Bruce Davidson—were doing very good

things. The picture was unlike classic surrealism, yet far from the reality seen by others who snapped up visual souvenirs in the neighborhood of that railroad station that day. *Rolling Ball* was a precocious definition of the game Turner would play from then on. In making it, he established all at once, once and for all, his own beguiling set of rules.

During subsequent years, as Turner's trips and triumphs became more numerous and his clients more generous and more demanding, he went on refining these rules, expanding the game, by continuing to make pictures for himself. When assignments came from magazine editors, as many of his early assignments did, his most personal pictures were usually what ended up in the magazine. But it is a central irony of photographing for a living that the best living is made at the most commercial level, taking pictures for clients who tend to demand the most, but often *want* the least. What they are likely to desire isn't the Pete Turner who made, say, the greatest cheetah shot ever, or pictures of an Icelandic volcano that Thor himself might have commissioned; what they probably want is the Pete Turner who can deliver exactly the kind of pictures needed precisely when they're expected.

Advertising may sometimes be art, but at all times it's selling, and in selling, timing is everything. For even the best advertising photographers, the kind of varsity stars who get sent off with support staffs and helicopters and high five-figure-per-image budgets, what matters first is getting the job, and then getting it done. Agency account executives rarely, if ever, lean back in their Herman Miller Equa chairs and say: "Surprise me." Personal vision is fine, as long as it doesn't interfere with the message.

Yet despite the restraints on his time and the restrictions on his artistic license, Turner manages to keep on slipping notes to his psyche, or muse, or what have you. In this dazzling book appear one hundred of those intriguing notes, highly personal shards of vision gathered up from nearly thirty years' worth of trips and assignments, which ranged from good to godawful. What these pictures represent is nothing less than the stuff of a determined and continual renewal; as messages from the self, they have made a remarkable and indefatigable artist of the man who made them.

Pete Turner, seen at ease in his ninth-floor Carnegie Hall studio/fiefdom, is not a particularly glamorous-looking man. His more or less constant winter uniform consists of a turtleneck sweater, blue jeans, and black cowboy boots that have seen many miles (if few stirrups). Turner is tall, with an affable, loose way of moving and a slightly bemused smile. There is something definitively American about him, more than a hint of the Southwestern "good old boy," however unexplainable that may be in someone raised in upper New York State. Yet he doesn't seem particularly concerned with giving that "down home" impression, or any impression, for that matter. Twenty-five years ago he didn't look much different, discounting the inevitable mischief of time and gravity. Whatever affectations might have arisen with prolonged success in an infamously self-inflating field seem to have missed him. The sheen of his high rank among the top photographers in New York City glimmers nowhere on him.

Not that life is drab. He has a splendid glass-walled apartment with a fine—almost Turneresque—view of the Chrysler Building, and is married to an even more splendid Frenchwoman. But in person, Pete Turner looks for all the world like somebody . . . well, like somebody named Pete.

Of course, no legitimate scholar or trustworthy critic would pay a second's attention to what a photographer looks like—the work is the thing, they would sternly remind us, not the tailoring. And yet Turner's unvain, unveneered appearance is not without meaning. As a kid, he grew up in the rather disorderly

world of his bandleader father, and can easily be imagined shy and tongue-tied among hip, garrulous horn players.

After several good years, his father's band ran aground on some bad times and the elder Turner went to work selling used cars. The family moved from Montreal to Rochester, New York. Looking for order and predictability, perhaps, eleven-year-old Pete stumbled onto that benevolent brownie, photography, fell hopefully in love with its curious but dependable chemistry, and—happy little nerd—plunged into the magic, and has never really surfaced since. All these years later, Turner's lack of any carefully calculated personal style is a manifestation of his complete absorption in the wonder of chemistry, and the chemistry of imagery. It is a manifesto, in a sense, of independence from any artifice but that in the image. His style is all there in his pictures. He isn't some craftily disheveled, genius-look self-parody. Turner is very together, very buttoned up; someone who knew.who he was and what he was all about early enough in life not to laboriously construct a persona while in search of himself as a photographer.

Not long after returning from the great Airstream adventure, having sold some pictures to various magazines and turned down a chance to enter photo Valhalla as a staffer for *National Geographic,* Turner was noticed by Harold Hayes, an ambitious ex-Marine then on his way to becoming the editor of *Esquire.* Impressed, perhaps, by Turner's ability to make visual sense of a long, disconnected trip, Hayes sent him off to "do pictures of railroads." Ever game, Turner packed up his cameras, got aboard a train at Grand Central Station in the summer of 1960, and tracked a vast circle that ended him up, one month later, a few blocks away at Penn Station. Once again, the trip was a success.

Hayes, with the fine indifference to logic that marks great editors, then suggested that Turner make the photographs for an essay on sophistication. The young photographer demurred: what did *he* know about sophistication? Hayes knew what Turner knew, whether or not Turner himself knew. The editor didn't need someone who could tell which spoon the caviar called for, or why a paisley cummerbund was not quite right. What he needed was somebody who knew instinctively, in back of his eyes, what a photograph was; that was the kind of sophistication which really mattered, and that Hayes knew Turner had in abundance.

In fact, looking back on those days now, it is clear that Turner was more sophisticated than anyone knew. He lusted after color, of all things. During the early sixties, for instance, purely serious (and seriously pure) photographers did little, if any, work in color. The printing, usually done by others at labs in unlikely places like Rochester, was out of their control. And besides, everybody knew that black and white was the medium of art.

But Turner did color and nothing but color, printing himself, reveling in the formulas that others found arcane and off-putting. Certain photographers could work wonderfully well with color—Irving Penn, for one—but disdained it despite their successes. Turner delved ever deeper into his chromatic fantasies, unconcerned about whether what he was doing was art, or commerce, or some disrespectful combination of the two. Then, as now, pictures were his preoccupation, and not the gnarls and nigglings of high aesthetic debate. Color may have been the unloved handmaiden of Madison Avenue, but given a choice, most magazine editors would go for it every time. By following his Kodachrome creed, Turner was fashioning himself the very model of a modern major magazine photographer. These days, one is hard-pressed to find anything more than token black and white in most magazines. Turner's only surprise at that turn of events may be that it has taken the world so long to catch up with him.

Sophistication, Turner style, extends far beyond the simple idea of photographing in color, or determining to do so when that was an offbeat notion. He was prescient, as well, in his realization that photography need no more be tethered to the actualities of color than painting; that sky blue, grass green, and all that was not an edict from God for photographers any more than it was for Van Gogh or Matisse. Color was color, with a life of its own, and Turner decided brashly that he could do whatever he wanted with it. Why shouldn't the sky behind a silhouetted giraffe be a lurid, dawn-of-the-earth red? No reason at all. Certainly *not* the reason that such a color had never passed before Turner's lens. He had been in a certain place, and the giraffe had been there at the same time, and the necessary chemistry existed to give Turner the sky he wished. Thus, in his way of thinking, his way of *seeing* was at least as right and logical as mere reality.

But curiously, having made this considerable leap into a kind of photographic fauvism, Turner didn't turn away from the power of color as it is—the plain facts of blue sky and green grass—astonishing enough on its own, really, and all the more so when seen with the intensity of Turner's turbocharged eye. The luminous blue of a whitewashed fortress in the moody light of a Mozambique dusk, the fierce sun-zapped yellow and red of a plastic refuse can on a Florida beach, a big cat burning bright in the nightmarish pale green of some primordial plain—all these waited out in the world to be seen, and needed only the likes of Pete Turner to see them in the way they deserved. As brilliant as he can be in the exotic agriculture of raising hybrid images, Turner has always been a hunter/gatherer of the highest order.

Even at his most outlandish, he has never asked color to do his work for him. The gloomy, forgettable brigade of seventies photographers whose work was said, with reverence, to be "about color," had nothing to teach Turner; alas, they seemed incapable or unwilling to learn from him. However much technique and manipulation may go into a finished picture—sometimes enough shaping and polishing to shame a veteran diamond cutter—Turner has been somewhere and brought back something extraordinary. Whether the picture is an absolutely straight shot of a woman's hand holding a grape, a fierce light making a mock X ray of the exquisite bit of fruit, or an imagined landscape with a blue desert, a stormy sunset, and two impeccable cue ball moons, the content steadfastly carries the weight of an image's meaning. As Turner puts it, tersely Turnerish: "You have to have something to say."

What makes Pete Turner's private stock, of all vintages, age so well is that he has so much to say, and so many ways to say it. There are real pictures, and surreal, and super-real, invented pictures, and more than a few very nearly demented pictures, yet all of them are, somehow, recognizably Turner. After so many years of playing variations on his themes of spheres, outlandish landscapes, fabulous bestiaries, roadways diminishing toward the land of id, and trans-transcendental women, Turner seems hardly to differentiate between seeing things more or less as we see them, and showing us what only he can see. It is all prime-time Turnervision, and as often as not it's hard to know exactly at which end of the actuality curve we're encountering him.

Chance favors the prepared eye, as any third-rate photo guru will tell you. Certain photographers seem to conspire with fate to have the world at hand arrange itself into picture possibilities. Surely, when Henri Cartier-Bresson strolls down a street, shutter finger poised, things happen simply because he is there. How else can his uncanny choreographies of happenstance be explained?

In the same way, from time to time, the world will arrange itself into a Turner

composition. On occasion, it can go to considerable extremes. One morning in 1973, for instance, Turner picked up the *New York Times* and read about a volcanic eruption in Heimaey, Iceland. A new plot of the earth was being created, and an old town was being buried in the process. Turner was on a plane that night.

The trip was one of the many therapeutic journeys Turner takes to peel his eyes when he finds himself going a bit stale; a search for personal pictures to get his pictures personal again. Steichen called the process "kicking the tripod"; Turner calls it "cleaning out my head." For some photographers it means changing subject matter, for some changing cameras and film, for some few self-dramatists changing wives or husbands. For Turner it usually means plane tickets.

When he got to Iceland, Turner found a scene so thoroughly made for him that it might well have been made *by* him. Looming up behind a storybook town of fastidious clapboard houses, like some apocalyptic demiurge, was a dark bulge of ash and cinders on its way to becoming a mountain. In a matter of days it would engulf the town, whose houses already stood forlorn and empty amid banks of ash like drifting black snow.

Thus, coming back from the hellish scenes at Heimaey with what must surely be some of the most eerily dramatic photographs ever made, Turner pronounced the event (in the vanished vernacular of the early seventies) the "ultimate reality trip." Photographically, the volcanic scenario was a reality, and a trip not likely to be repeated, and Turner decided to spend more of his time making pictures that would depict worlds of his own creation—to echo that dark scene of creation in Iceland. He had already been experimenting with surreal photomontages for several years, but after Iceland Turner began to perfect the methodology and the machinery that have made possible an almost limitless revision and reinvention of his pictures, a phenomenal game of mix-and-match that has resulted in a private stock more private than ever but not a bit less astonishing than before.

It became Turner's particular form of alchemy to turn gold into different gold, taking pictures that he'd done here and there and making them into pictures from some other place entirely, the same way Baroque composers took their slightly used allegros, andantes, and largos and reshuffled them into completely original scores.

The possibilities were and are alluring, as so many pages of this book show, and for Turner—the unregenerate kid with the chemistry set—endlessly comforting, since he can make his own pictures now whenever he wants, trips or no trips, simply by climbing up a spiral staircase to a sequestered balcony loft in his Carnegie Hall studio and taking his projectors and optical printers to whatever mysterious places he wishes to conjure up. If he wanted, he could give up using his precious Nikons forever, give up first sources, and become a full-time miner of the Turner lode. Photography is a physically demanding trade, and the temptation never to go trekking with a camera out into the increasingly trammeled world must be strong, at least some of the time. The amenities of air travel aren't what they used to be, even for someone whose sojourns are strictly first-class. And, too, Turner isn't one of those dour, dogged opportunists who wear cameras incessantly the way others wear religious medals. When he takes pictures, it's never when he hasn't planned on taking pictures. The camera is a device, for Turner no more nor less, and he doesn't look as if he'd mourn for a minute should some stricter-than-thou fundamentalist group successfully lobby Congress to pass anticamera legislation. But don't be fooled.

Talk with a musician about his instrument sometime. For no particular reason,

single out a clarinetist. Given the wonderful sound of the clarinet, sultry or sardonic or melancholy, it might stand to reason that any player would feel great affection for the marvelous device. But no; chances are you'll hear a lament about its limitations and its obduracy, how reluctantly it produces any sound, much less a sweet one, how the fact that it won't double an octave has forced the inclusion of four extra awkward notes just to make the clarinet behave with the ordinary civility of the flute. Waxing frustrated, the clarinetist will carp about how impossible it is to get a reed just the right shape or resilience, and the maddening way modern clarinets don't match up with older music, making the fingering of certain pieces pure torture, and so on and on.

Much the same kind of admission might be made by a photographer, if honesty happened to be the prevailing mood. Without the camera, of course, there would be no photography. Yet a photographer's real concern is the act of seeing, with pictures themselves simply the motivation for that act, and its result. The better a photographer becomes at seeing, the more annoying it will seem to have to attend to such niggling matters as shutter speed, aperture setting, focal length, and focus, however close to second nature those arbitrary mechanisms may have become. The medium is the monster.

Like the clarinetist's instrument or the ballerina's vulnerable body, the camera represents a dour vehicle on the road to nirvana. Like racing drivers too spiritual to grasp the mysteries of turbochargers, some of the best photographers are boastful about how little they care about the technique and technology of making pictures, as if such knowledge might seem crass and contrary to their aspirations to art. If the camera could be eliminated from the formula, it seems they'd gladly do just that.

Not Turner. His education was distinctly old school, now somewhat out of fashion: technique first, aesthetics only when you know all the numbers and gizmos, and a minimum of time spent out by the reflecting pool with amateur Zen masters. Turner retains, even today, the qualities best suited to make the best of that kind of no-nonsense approach: the soul of an artist, the brain of a research scientist, and the heart of a hacker. From the beginning, Turner made a powerful alliance with the machinery of his medium, first because he knew that only by understanding its limits could he push those limits and himself along with them; and second, because he quite simply likes to fool around with the bits and pieces of wizardry that make photography happen. If Turner had been a racing driver, he would not only have known how a turbocharger works, but also how to get the best out of one, and how to take one apart and get it back together the night before a race. Cast your eye upward in Turner's meticulous, north-lit studio, and you will see twenty equipment cases. Turner may not necessarily take them all on any given trip, but it's unlikely he'll get anywhere and not have precisely what he needs. He isn't vain; he won't pretend that his extraordinary pictures just happen, that all he really understands is art, and that his well-drilled assistants do all the grunt work. Like a true master of the classic manner, Turner can do what he asks others to do, and he can do it well. Only the perks of his success separate him from having to sweat the details anymore.

Turner's ability to manipulate the resistant tools of his trade has the happy effect of encouraging him to try making pictures that will force him to devise ever more clever strategies. Though he won't come up with an idea just to see if it can be done (a techno-freak tendency that has given the world no end of trouble), there are few ideas he can't encompass within the stretched capacities of the camera and the capacious chemistry of color. In the late seventies, for example, Turner became interested in bubbles. "They're perfect structures," he says, as if no more need be said to explain his fascination with them.

Anyone who has ever been four years old knows that bubbles *are* fascinating, but photographs of bubbles hold out little promise of transmitting their magic (like Ph.D. theses on humor).

But Turner, consummate observer and craftsman, illusionist and dramatist, took the everyday miracle of bubbles and created—take your choice—moons, all-seeing eyes, a premonition of the surface of Jupiter four years before *Voyager* sent its pictures, paradigms of scientific observation, or simply abstract compositions of the most breathtaking sort. More important, they are pictures of tremendous quality, as perfect and astonishing as their subject, and yet they look so easy we might almost forget that a picture has been made. Turner, at the zenith of his abilities, almost vanishes from the transaction between his subject and his audience. He eliminates the sense of the camera at work the way Benny Goodman eliminates the sense of the clarinet at work.

Leonardo considered sight the sense through which we acquire knowledge and held that seeing was the equivalent of learning. For him, the art of drawing was the heart of knowing. Arguably, photography (which, after all, means drawing with light) is the ultimate draftsmanship, and those who do it best have the most to tell us. When Pete Turner goes off on his head-clearing sojourns and brings back giraffes and cheetahs, moody sphinxes, or men with pineapple-juice cans for earrings; or when he ascends to his Carnegie Hall flight deck and creates a cartography of places seen only in his mind, he is telling us about the world, and worlds within worlds, with the eloquence—and innocence—of a photographer who has worked his way up from success to wisdom. We do well to make his private pictures our private pictures.

One gray February afternoon Pete Turner, just back from a cigarette sojourn during which he and his camera did a great deal of profitable business, is inspecting a wall on which the pictures in this book are lined up rank upon dazzling rank. He is not in awe of these photographs, knowing as he does how much more than the godplay of inspiration they represent—how many miles, how much hard work and luck, how much polishing. But the wall chart of a lifetime of numinous images seems to reassure him that while his work-for-hire shooting powerboats from a helicopter dragonflying across the surface of a California lake will pay his bills, the bright rows of Cibachrome prints are proof that he has paid his respects to the muse.

He is asked by a visitor why a picture of a baby in a shiny yellow tunnel has been turned sideways so that the child, who had been lying down in the original version, now seems to float vertically a few inches in the air. Turner makes a rare, expansive gesture with his arms and exclaims, "It's just my way of fighting gravity." He thinks about this, then shouts, "Hell, I'm fighting gravity every day of my life!"

Gravity has its unbreakable laws, of course. Inexorably, year after year, it increases its pull on Turner. He is a celebrity, an officially Famous Photographer, a businessman who makes a lot of money and could work every day if he wanted to, a visionary beset by prosaic assignments, a seer who presses on against the tide of his own best pictures, and—no less important—a man now in his fifties with a teenage son who is making movies. Time and obligations add ballast every day to his once free-floating thoughts, and more than half the work he gets has less to do with what a wonderful photographer he is than how impeccable are his ways.

And yet, as is plain and wonderful to see by the evidence here before us, despite mounting odds to the contrary, in Turner's daily struggle gravity has always come out second best.

PETE TURNER

PHOTOGRAPHS

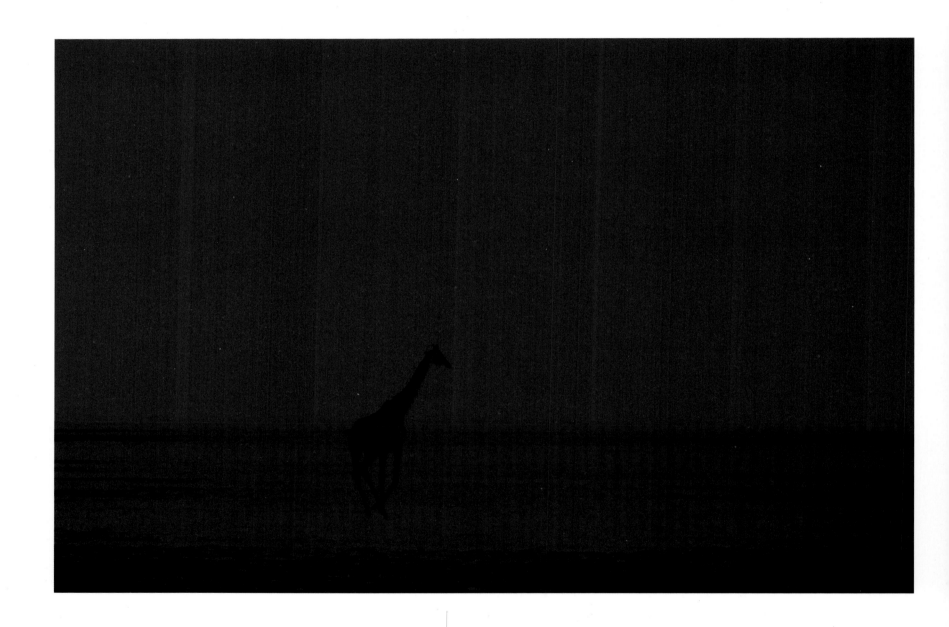

1. Giraffe

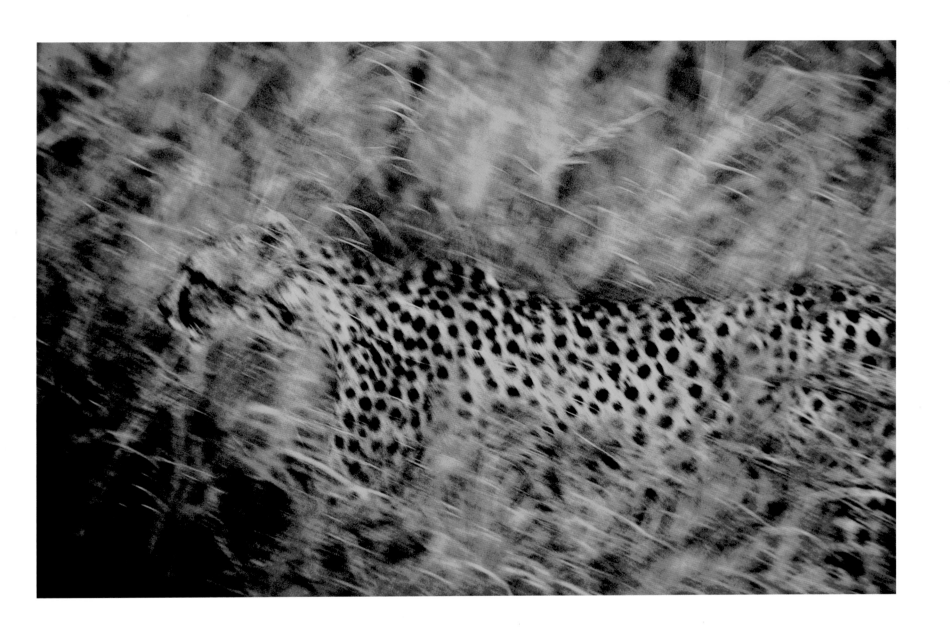

2. Cheetah

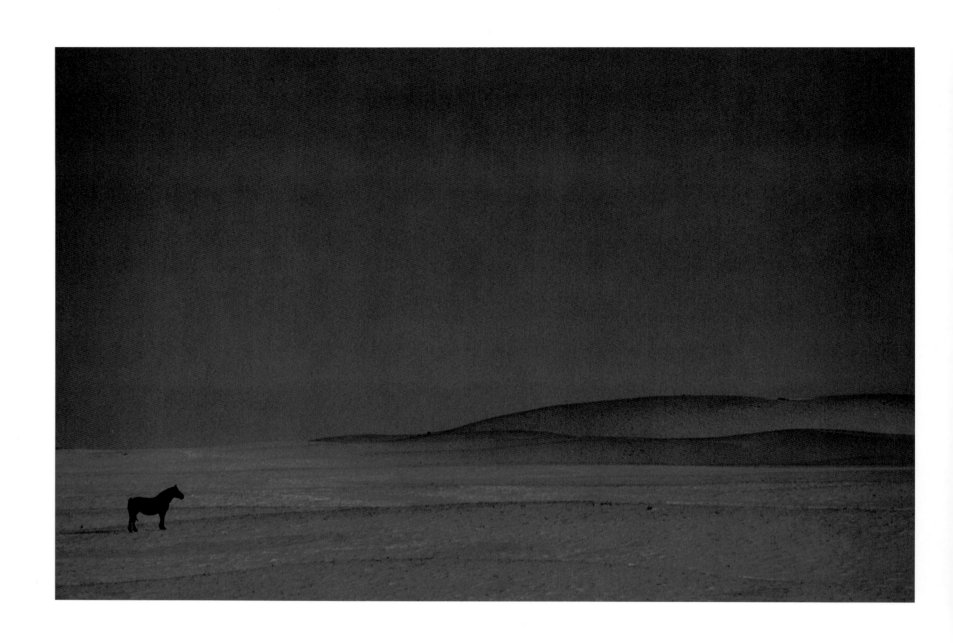

3. Blue Horse

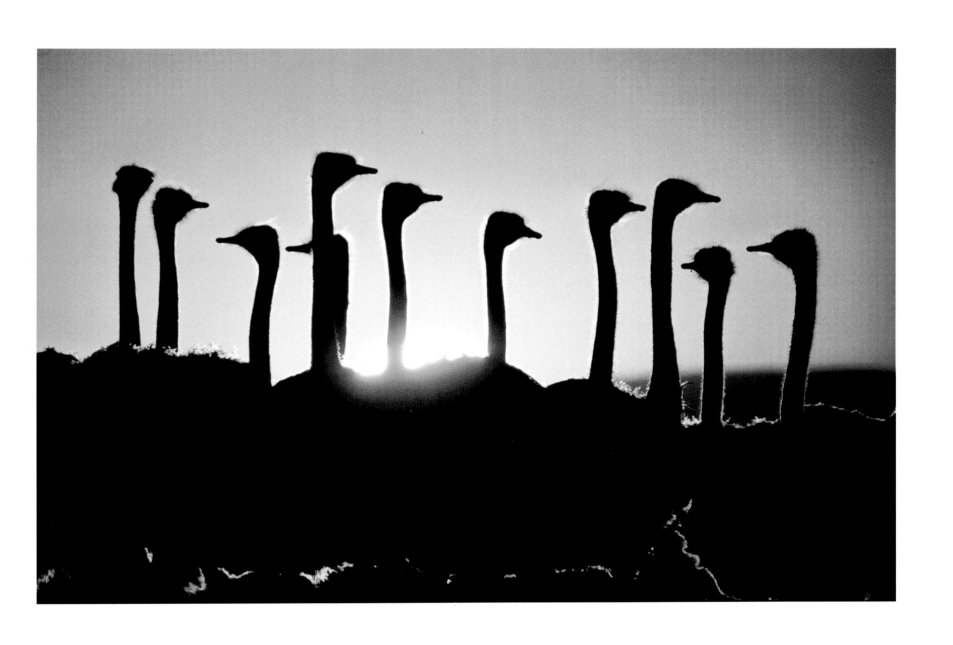

4. Necking

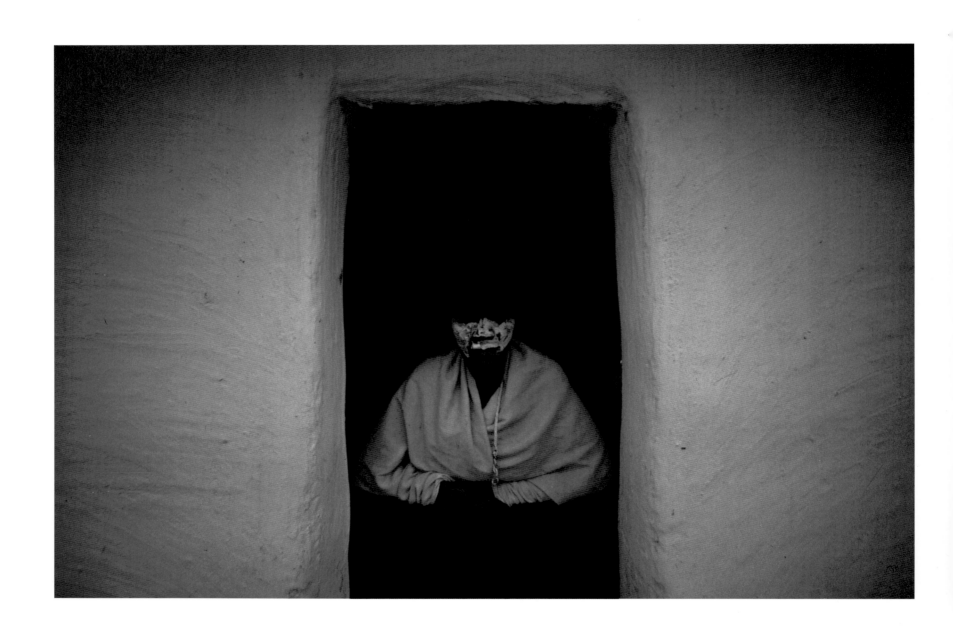

5. Pondo Woman

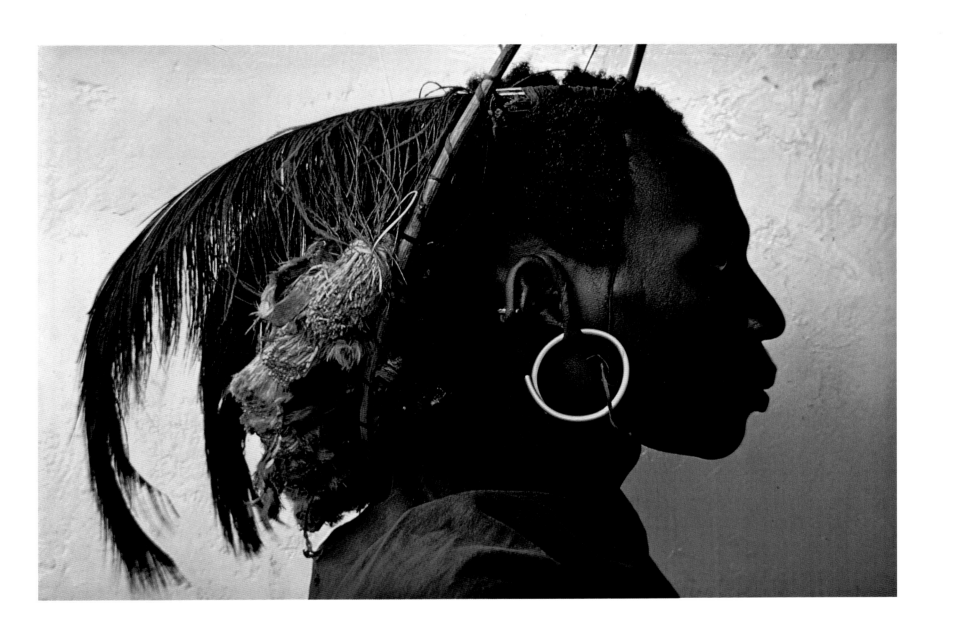

6. Electric Earring

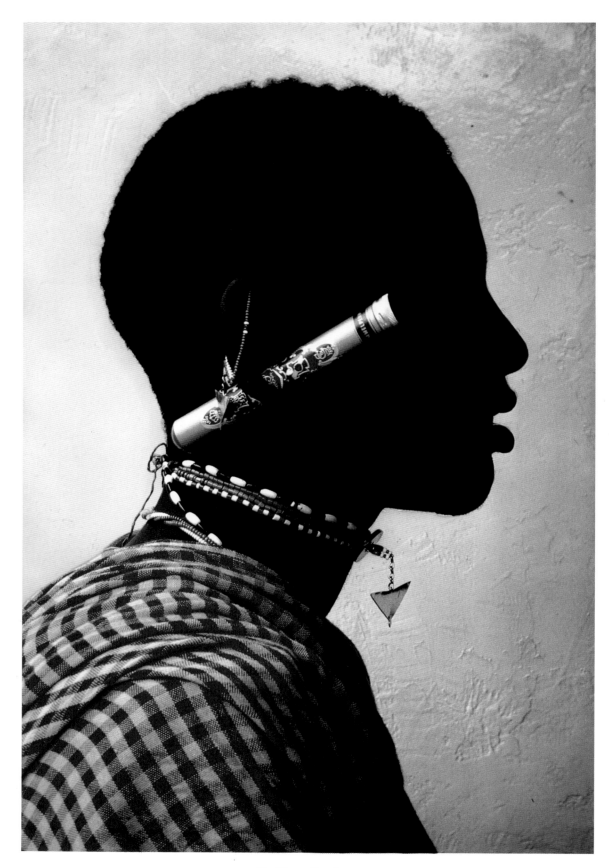

7. Cigar Earring

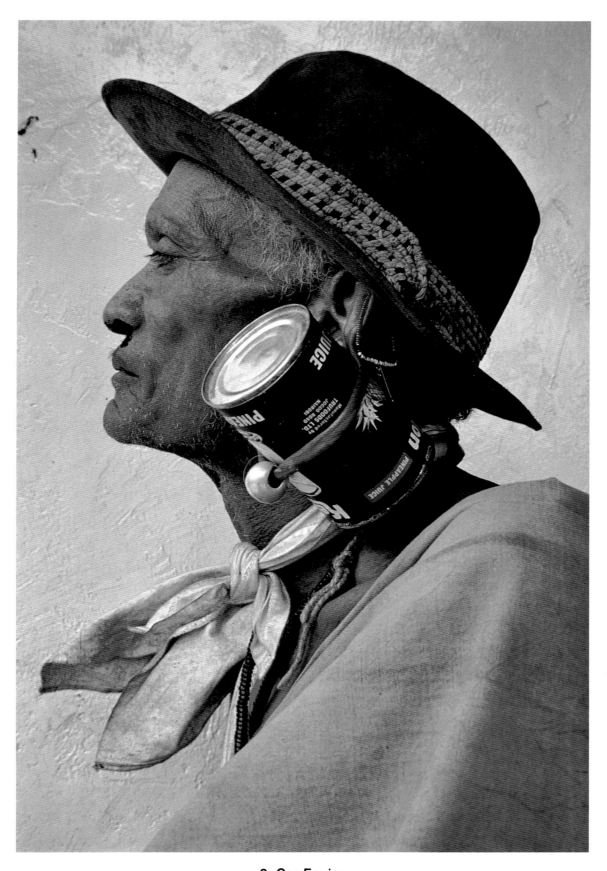

8. Can Earring

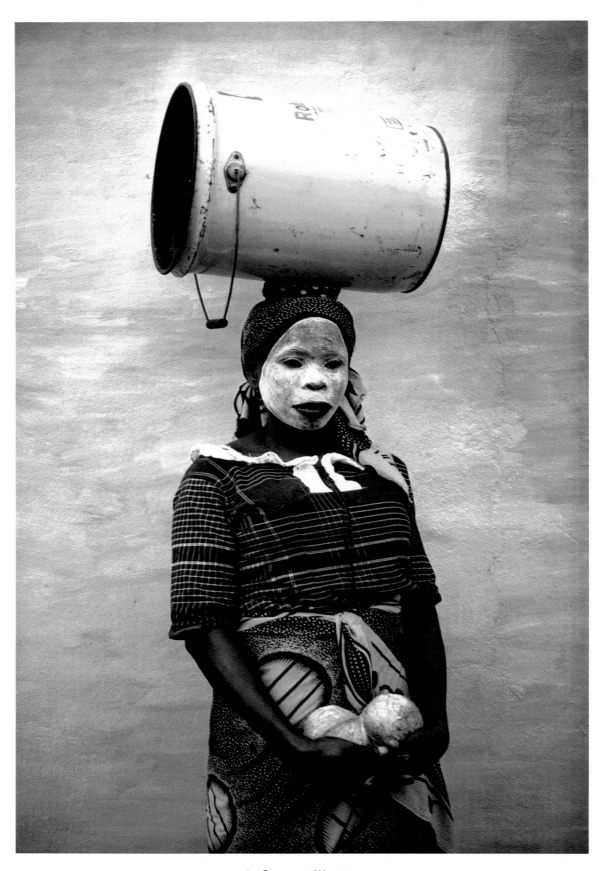

9. Coconut Woman

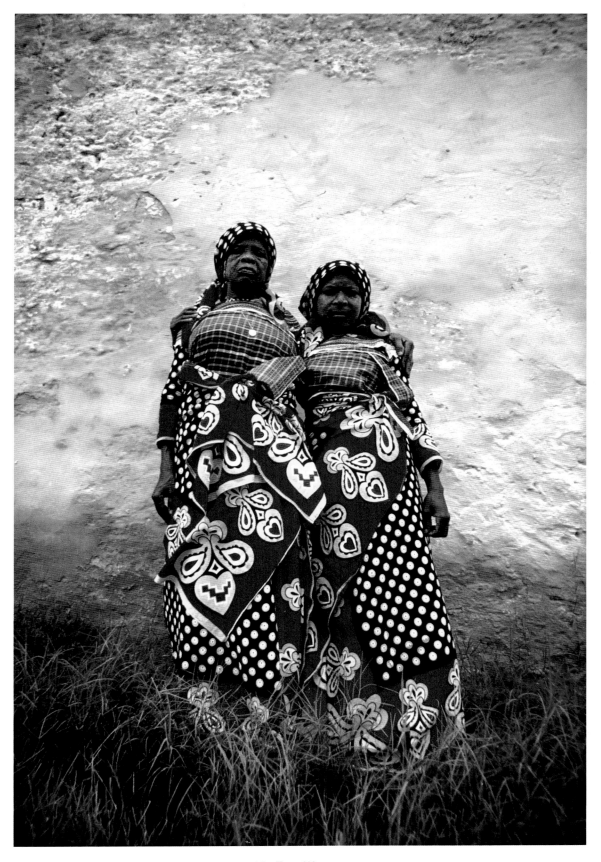

10. Two Women

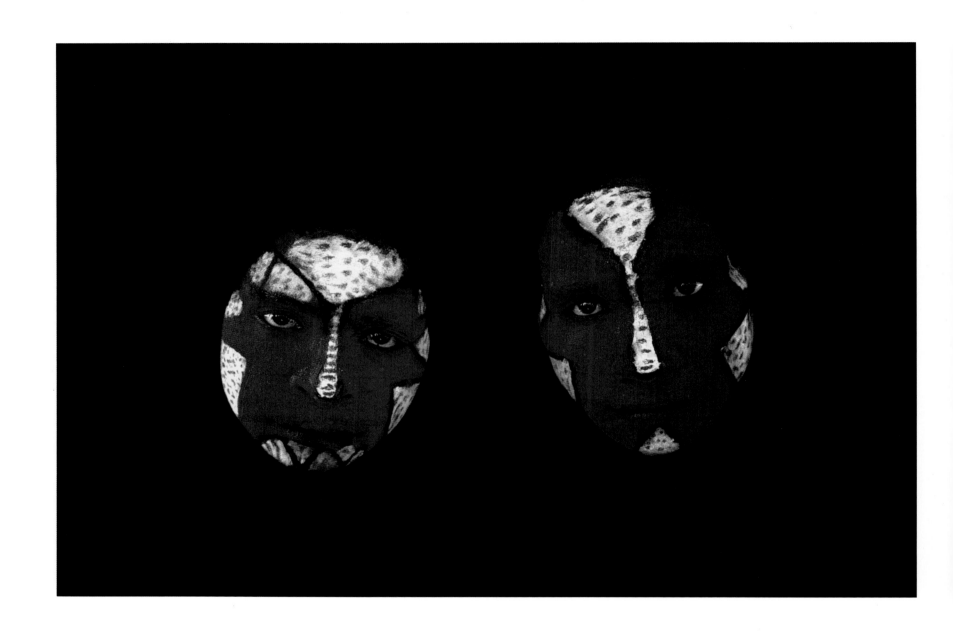

11. Twins

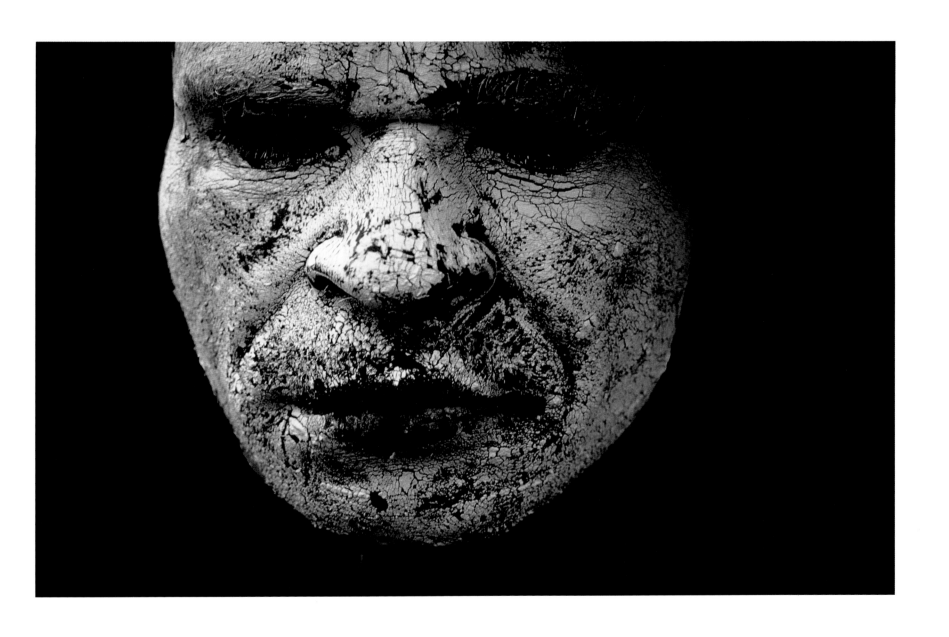

12. White Man

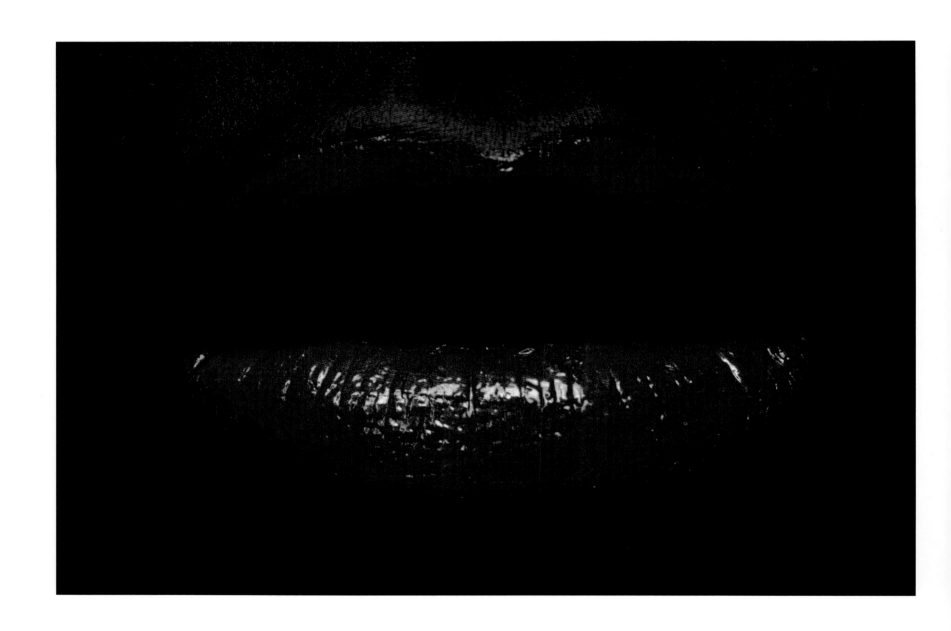

13. Hot Lips

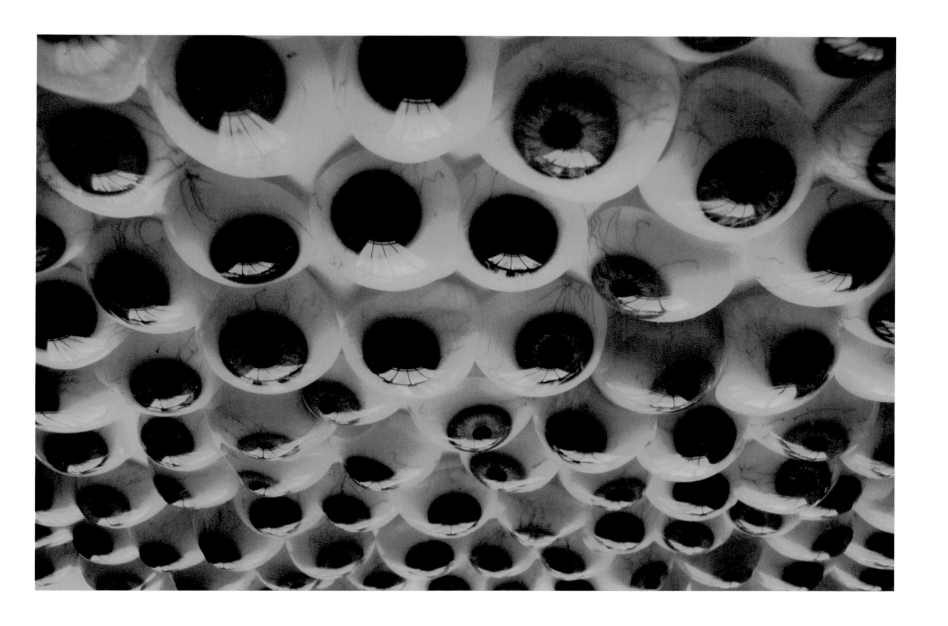

14. Soft Room

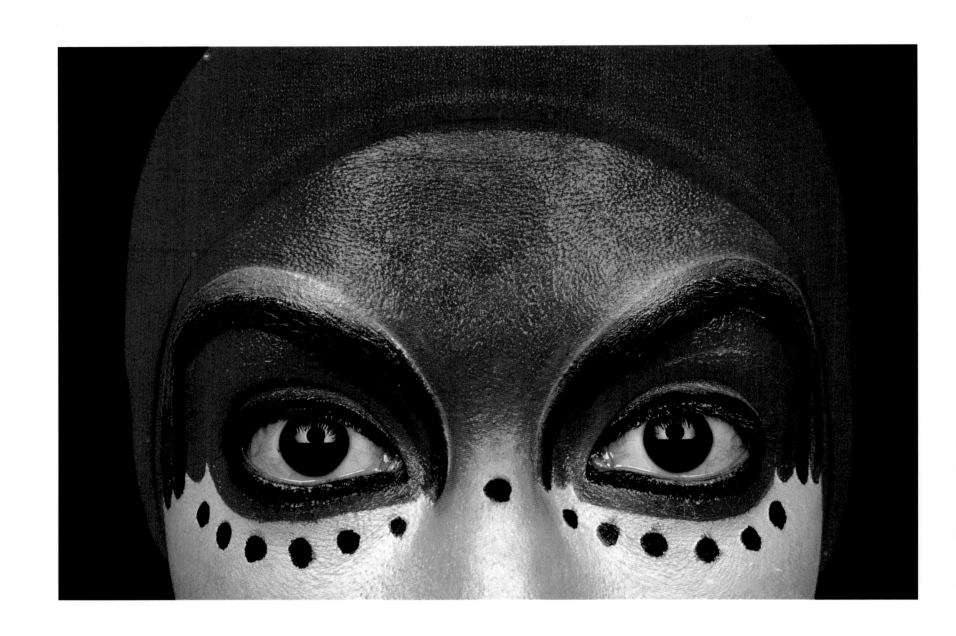

15. Reflections

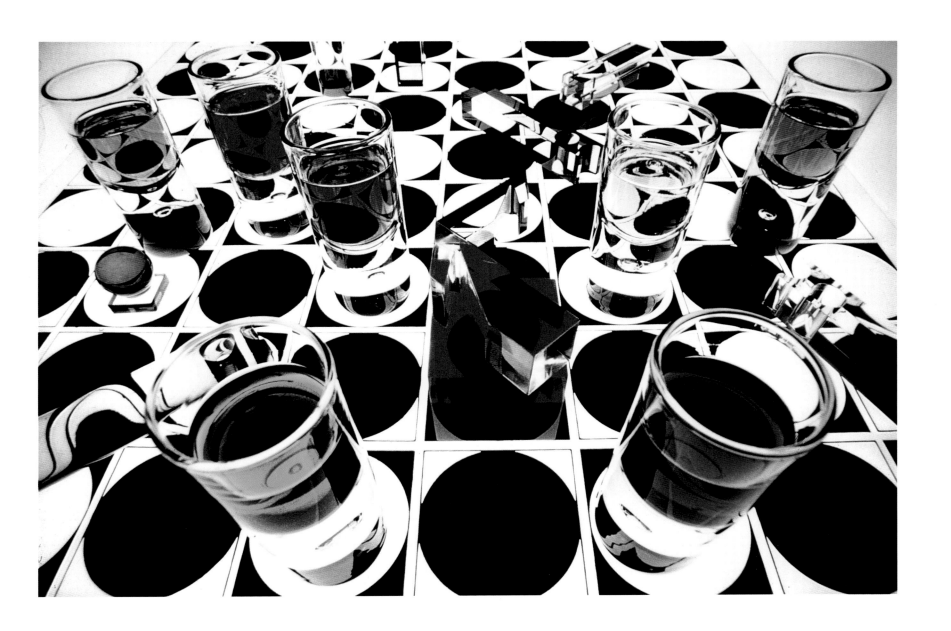

16. Chessboard

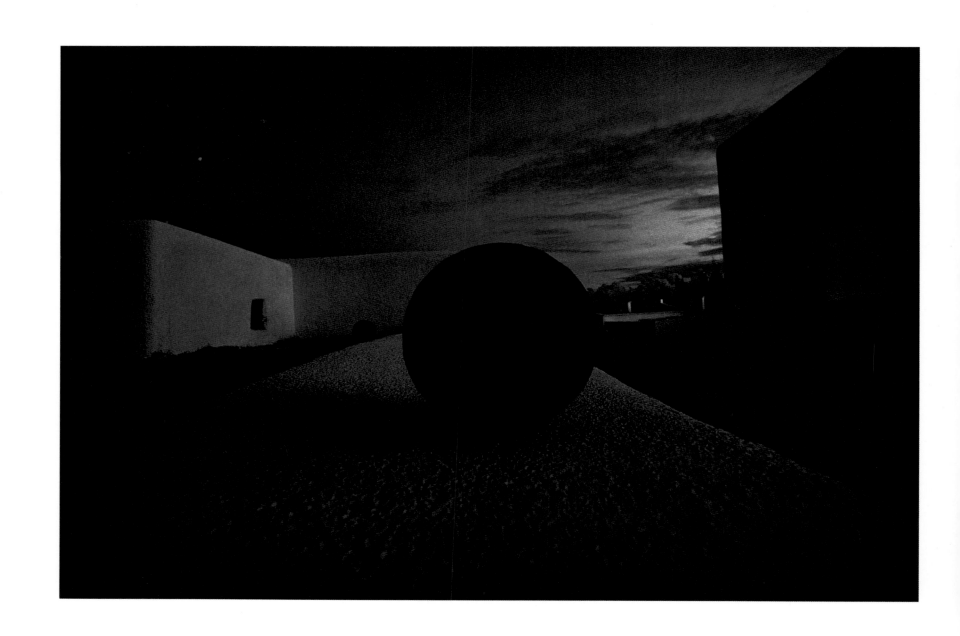

17. Cannonball

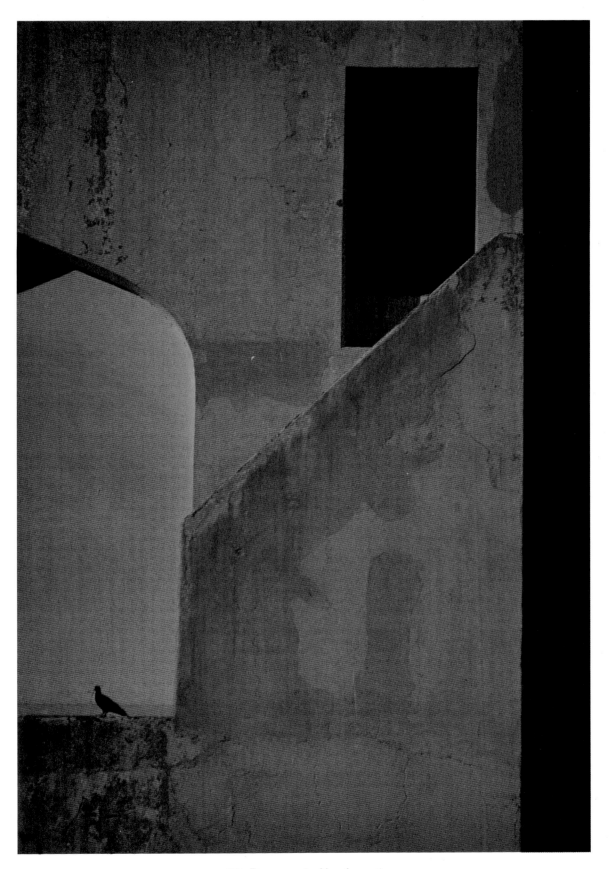

18. Doorway to Nowhere 1

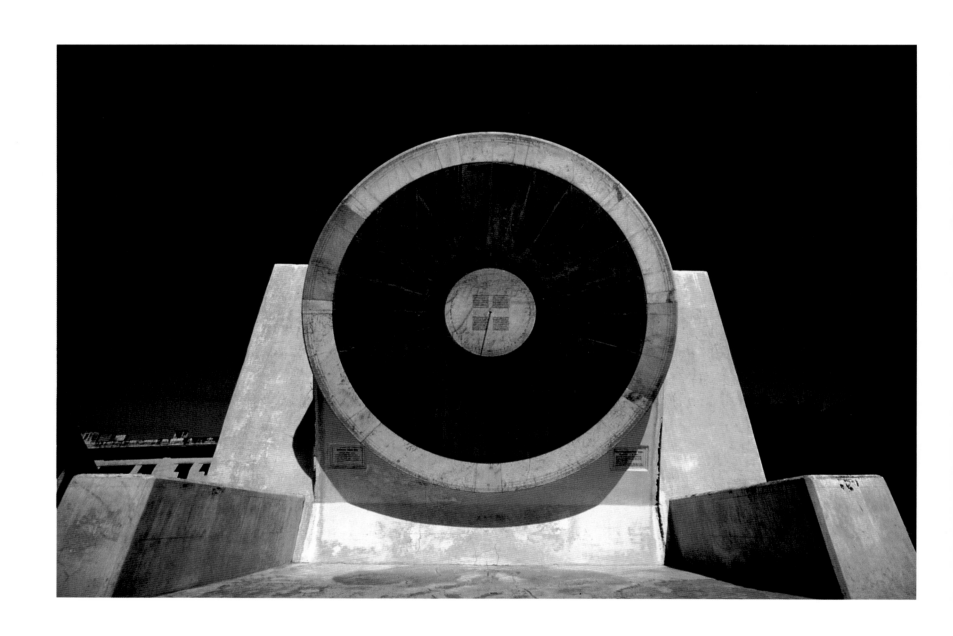

19. Monument to the Stars 1

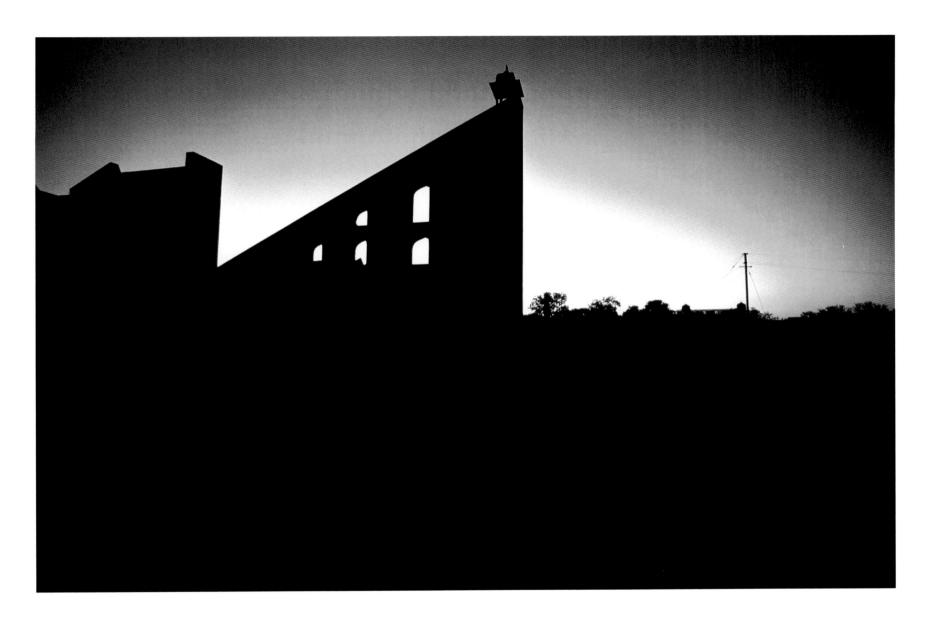

20. Monument to the Stars 2

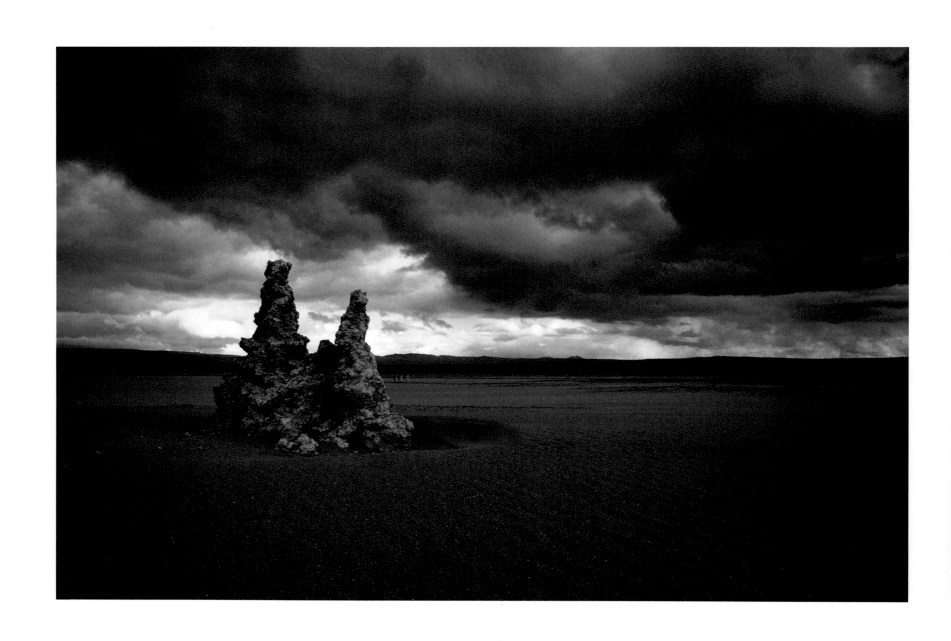

21. Sand and Storm

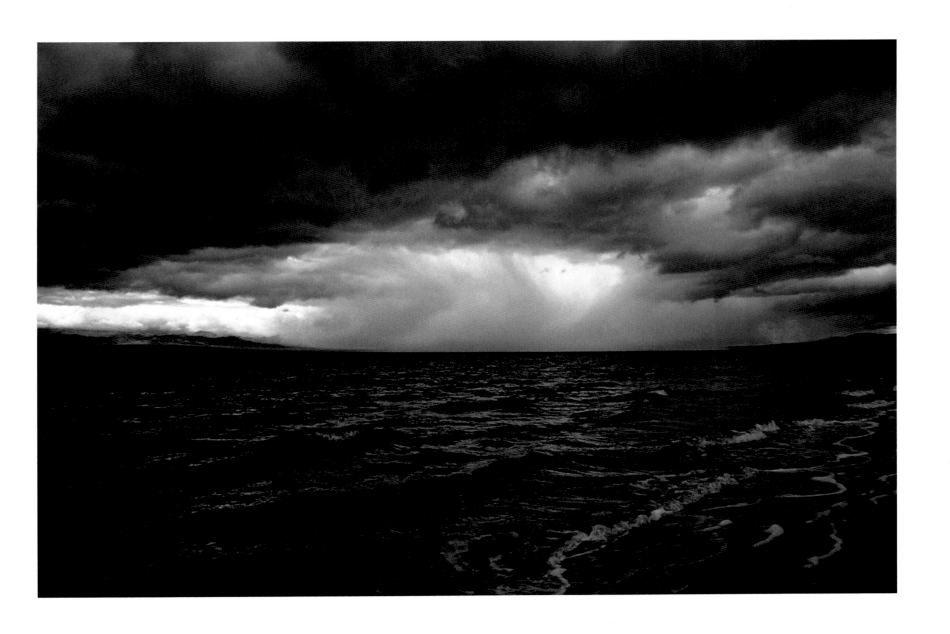

22. Water and Storm

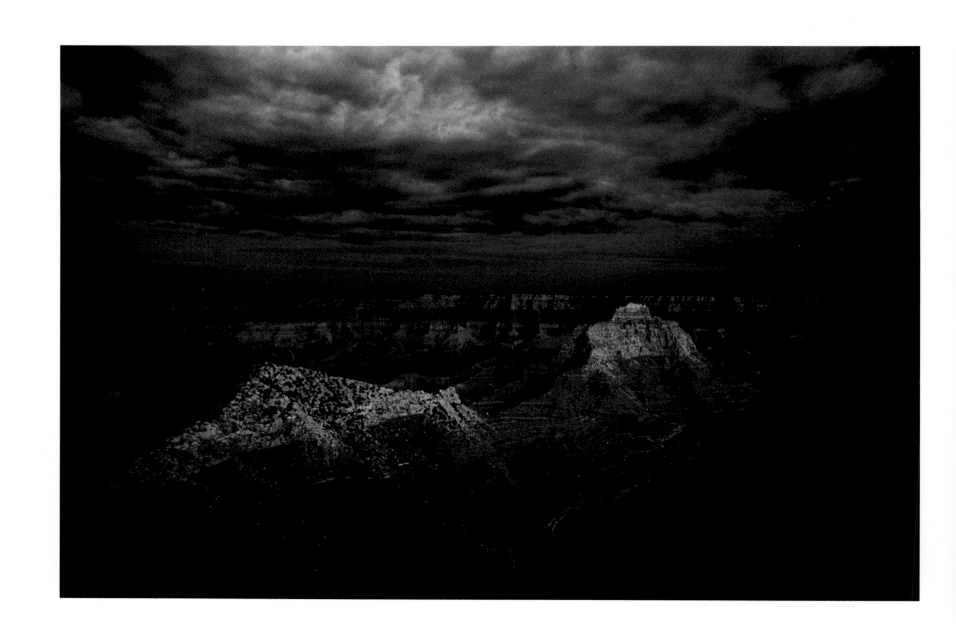

23. Grand Canyon

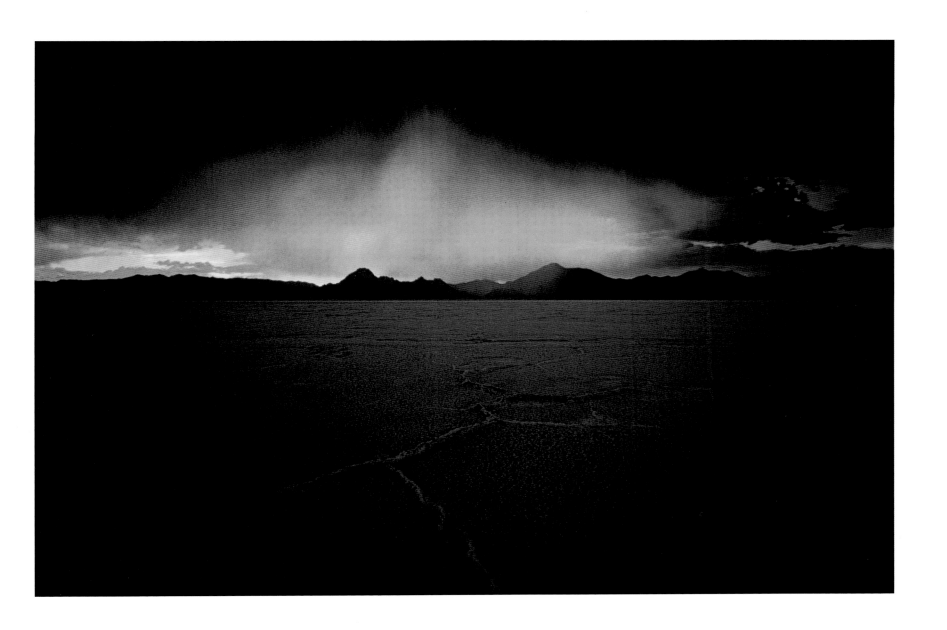

24. Salt Flats

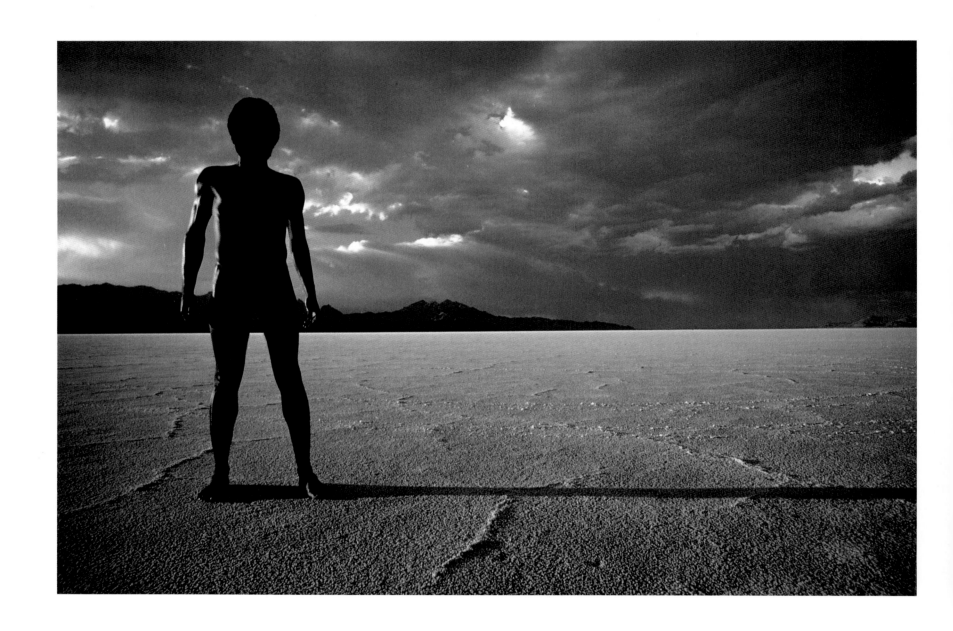

25. Man

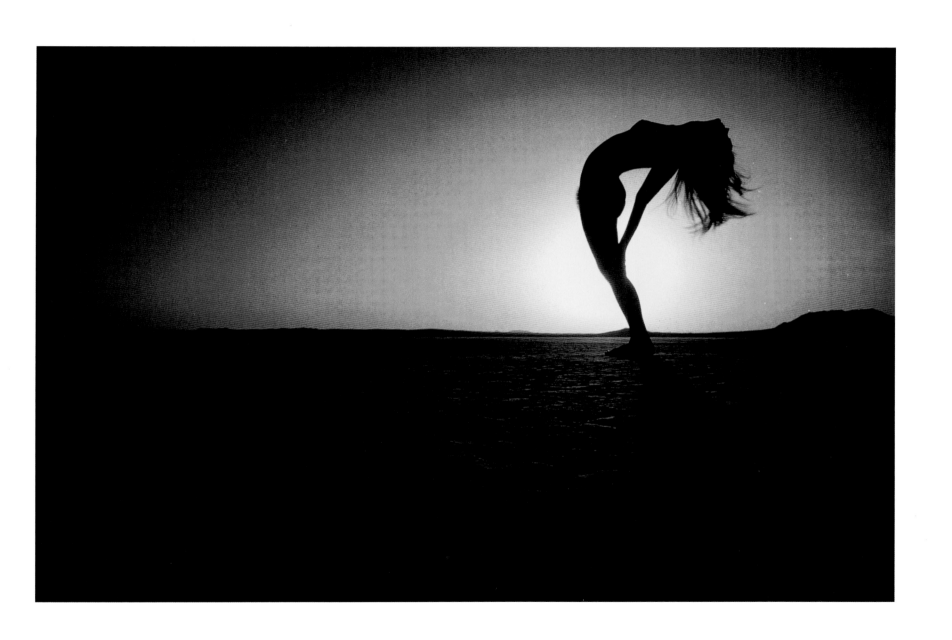

26. Woman

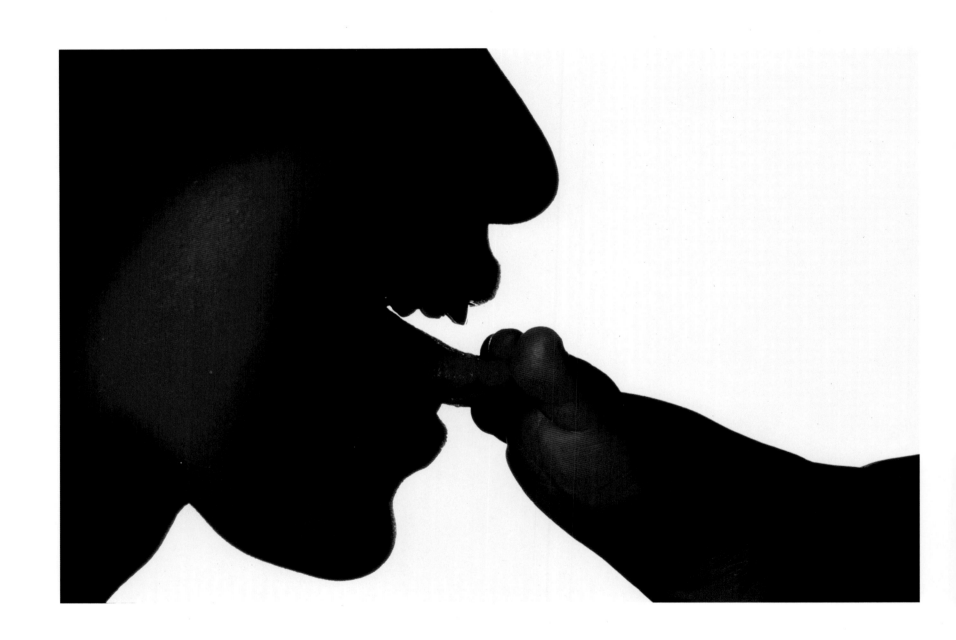

27. Licking

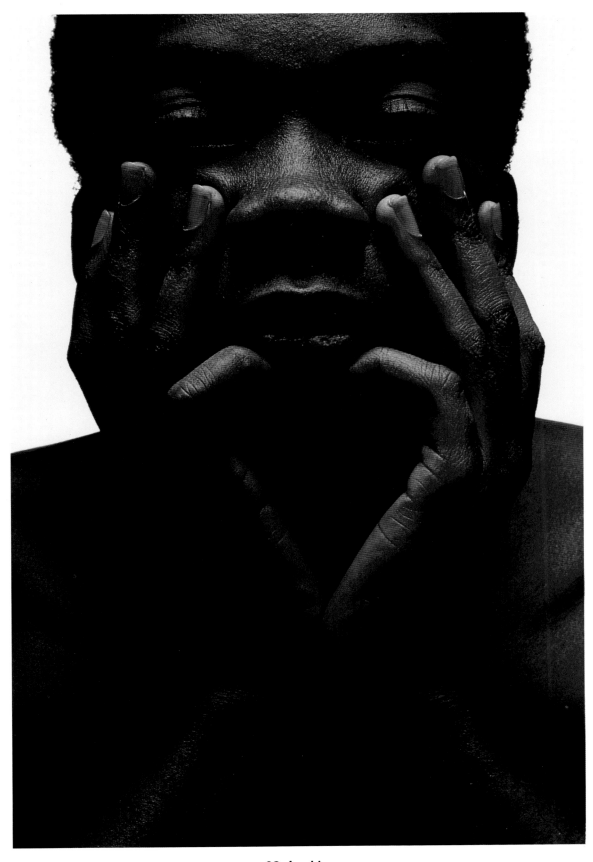

28. Looking

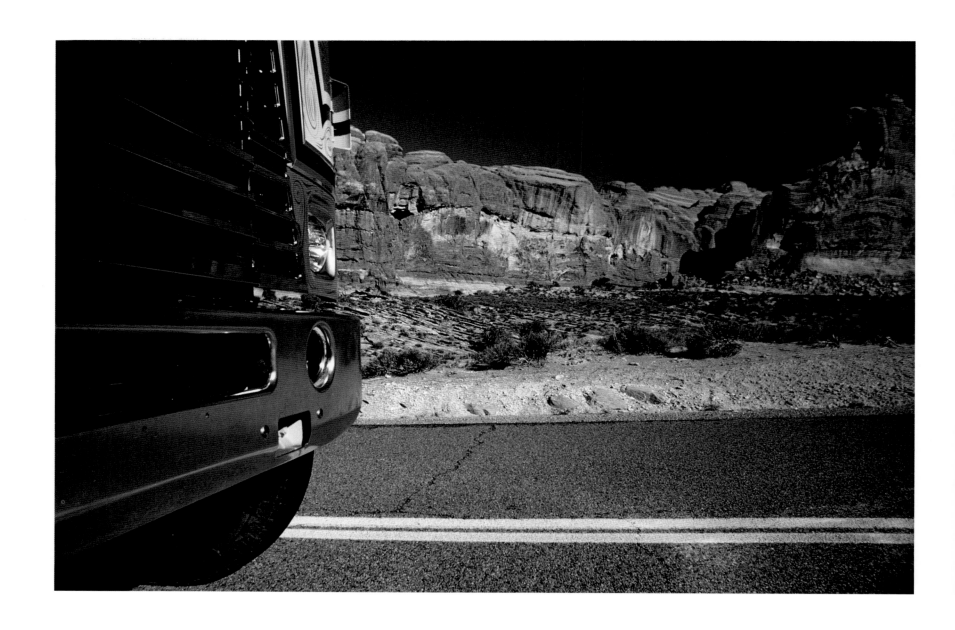

29. Truckstop

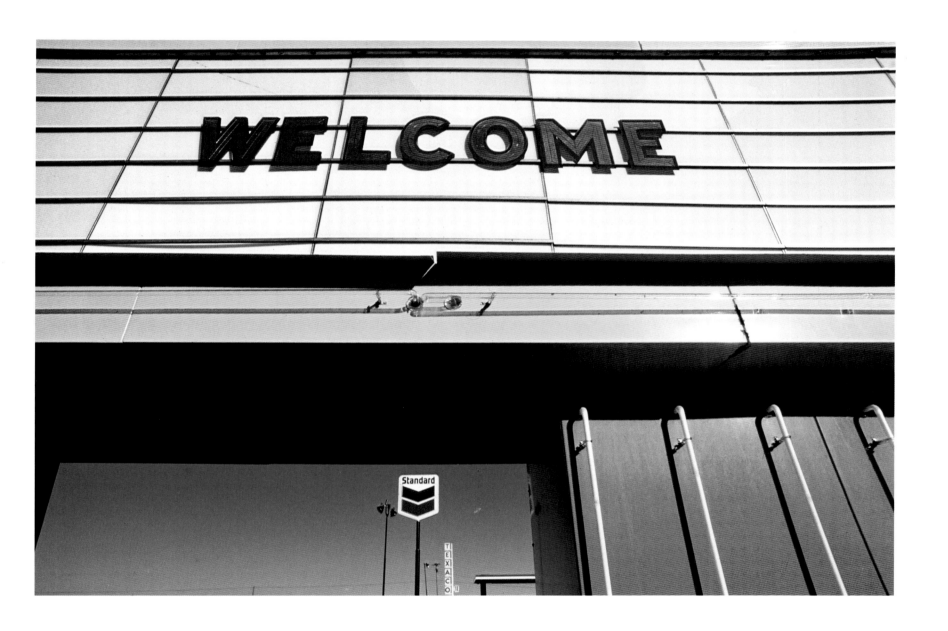

30. Welcome

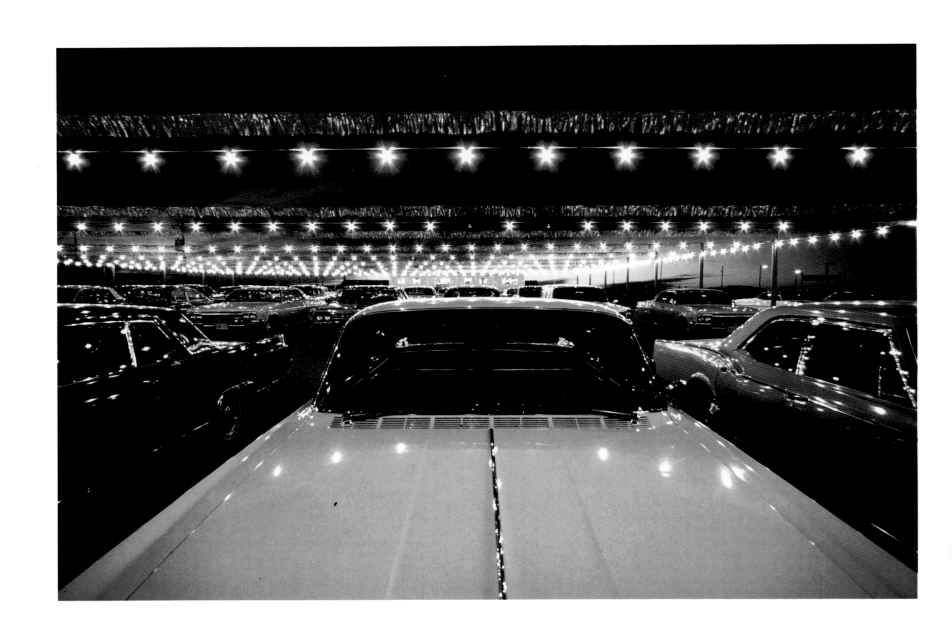

31. Texascape

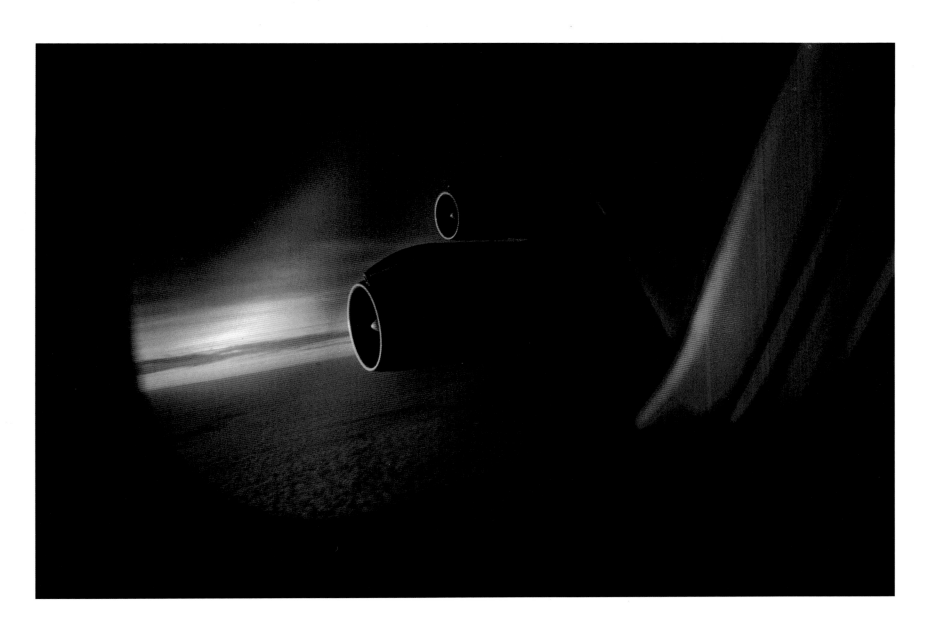

32. Feeling High

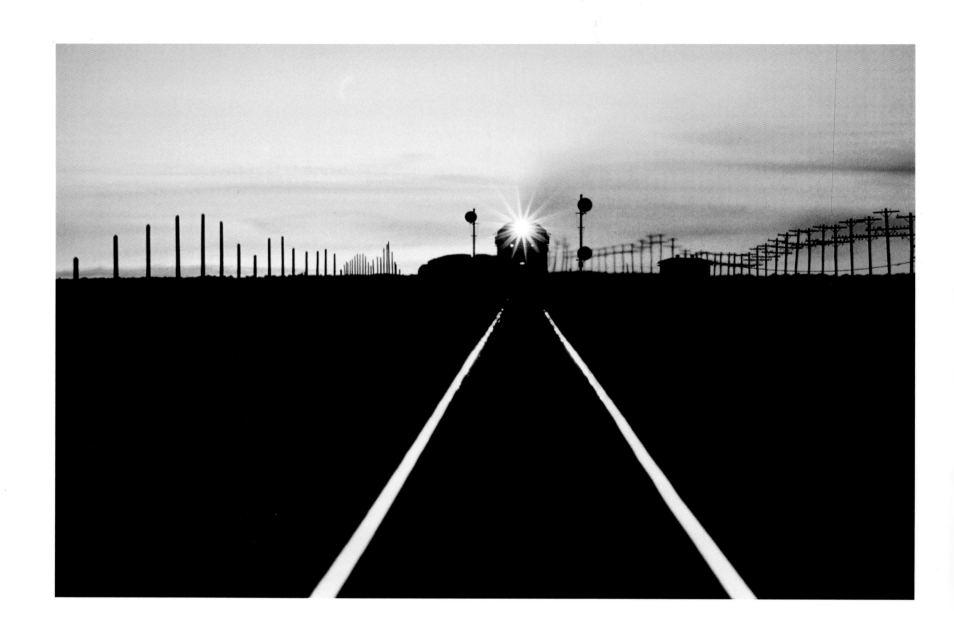

33. Tracks

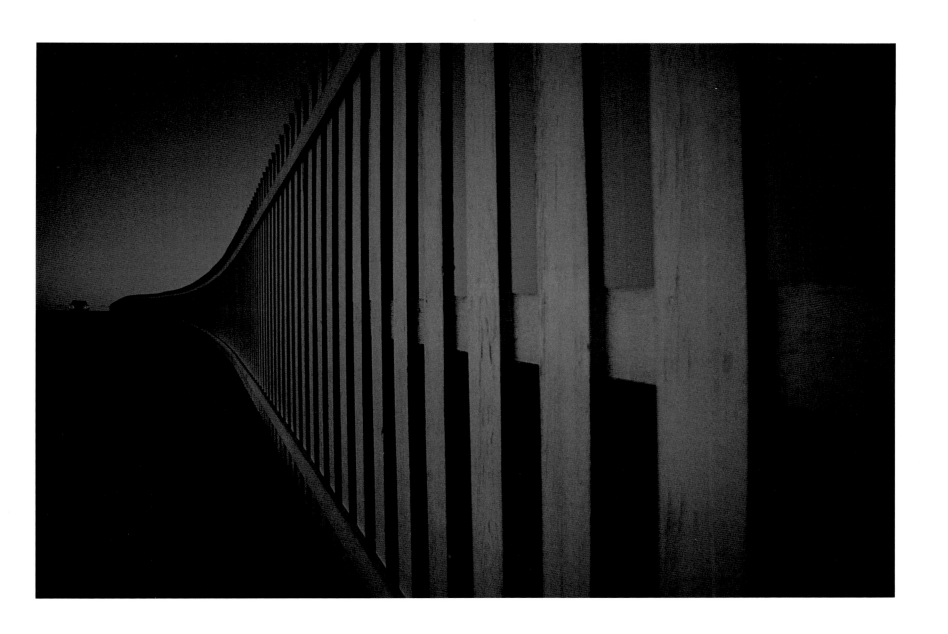

34. Road Song

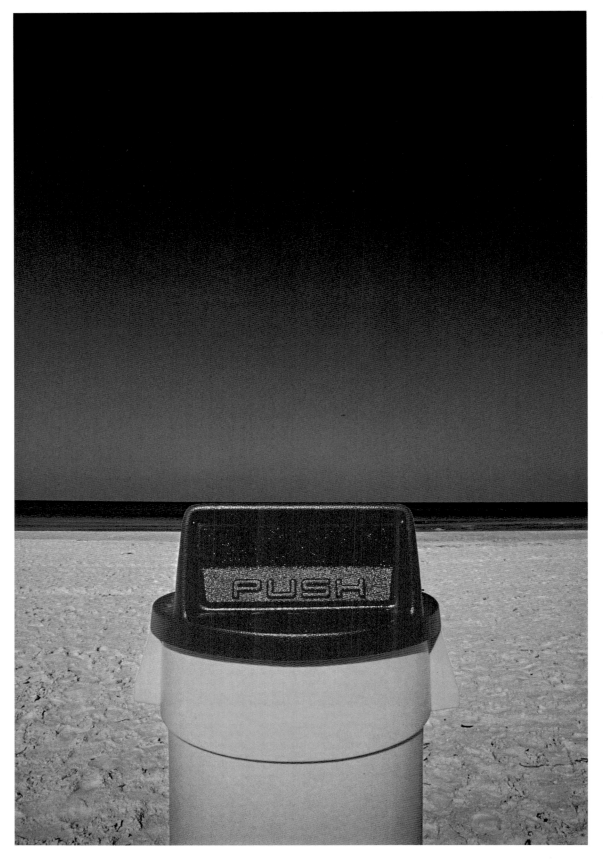

35. Push

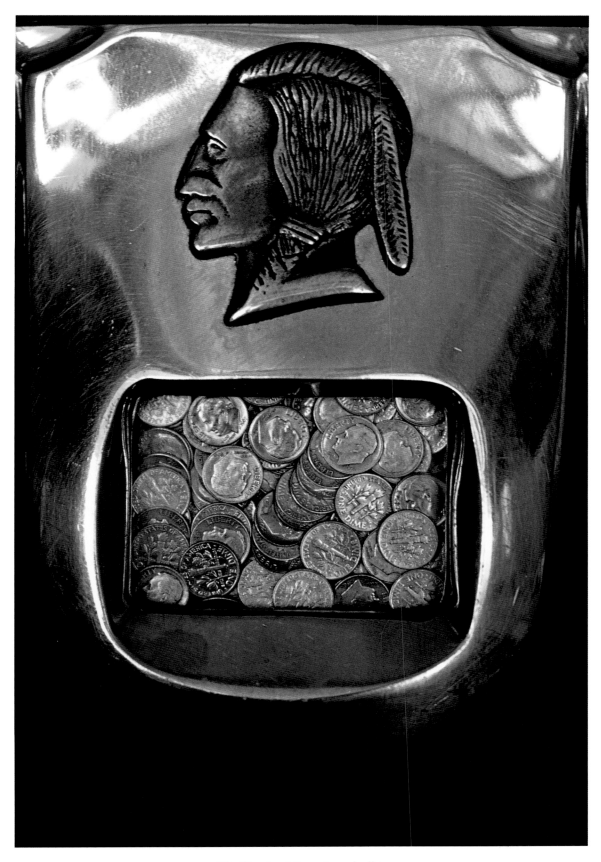

36. The Last American Indian

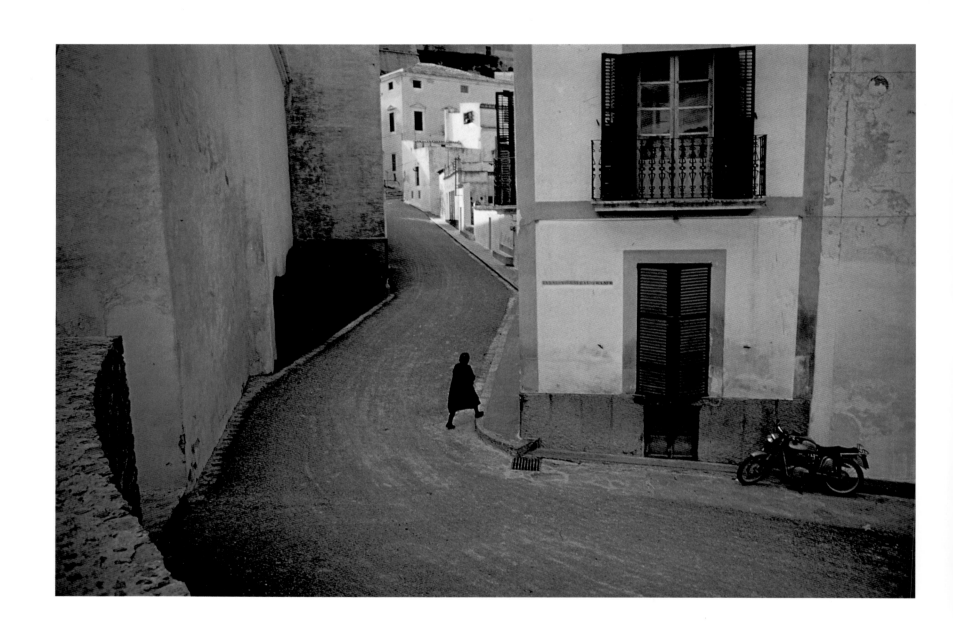

37. Ibiza Woman

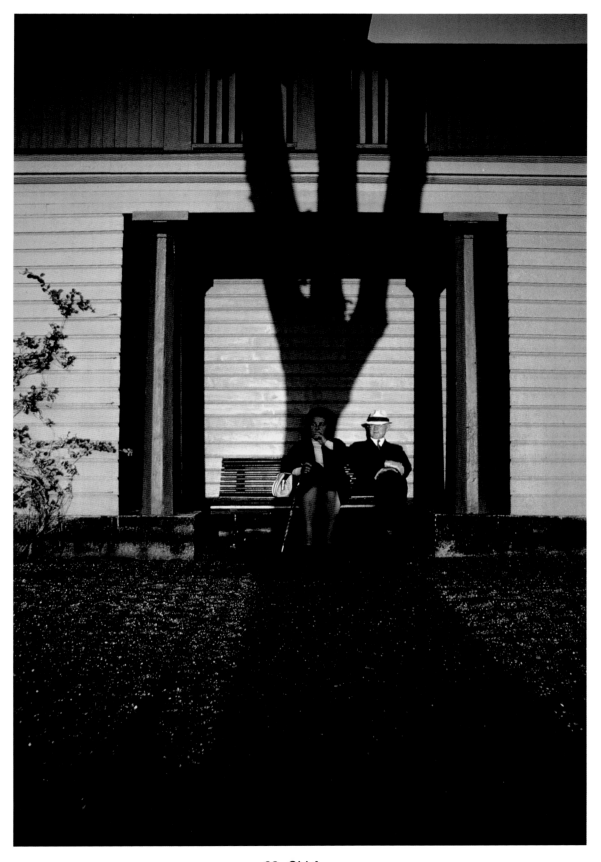

38. Old Age

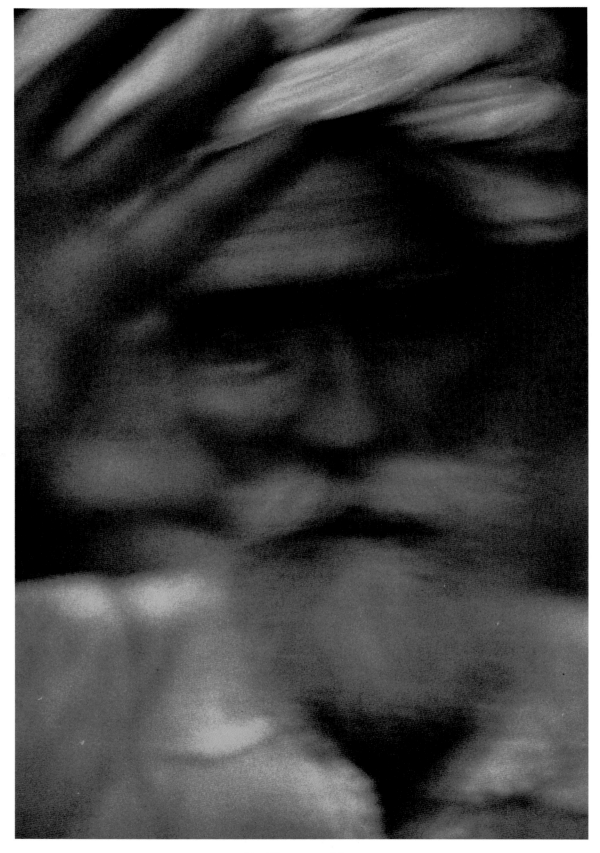

39. Singapore Man

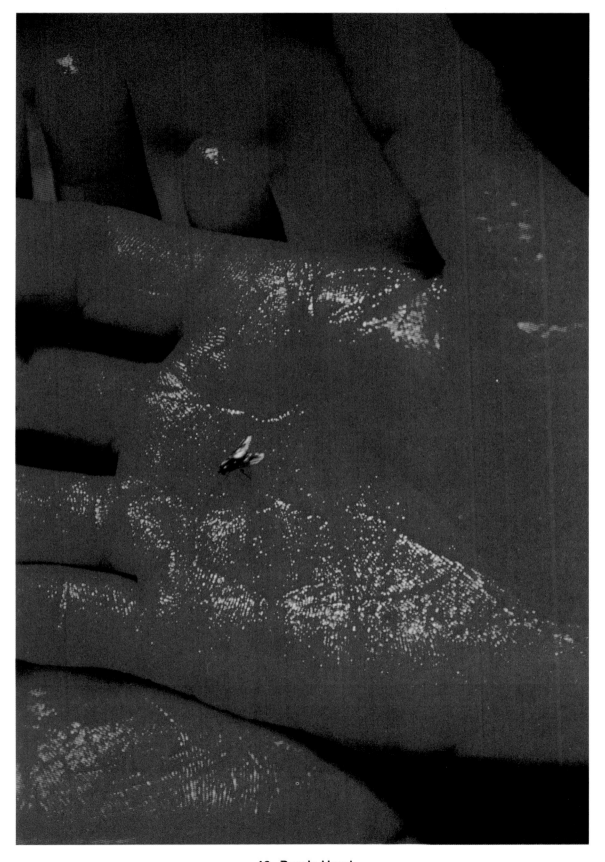

40. Dyer's Hand

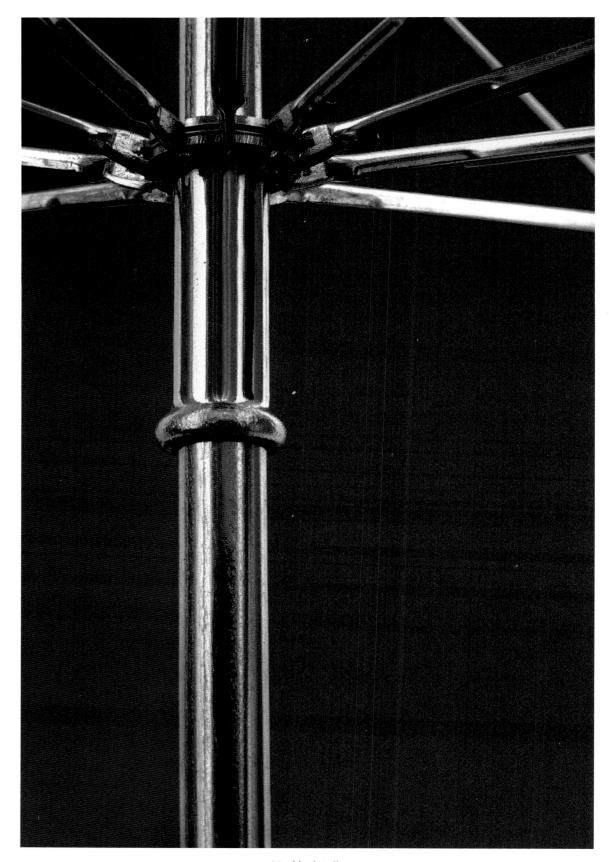

41. Umbrella

42. Aperitif

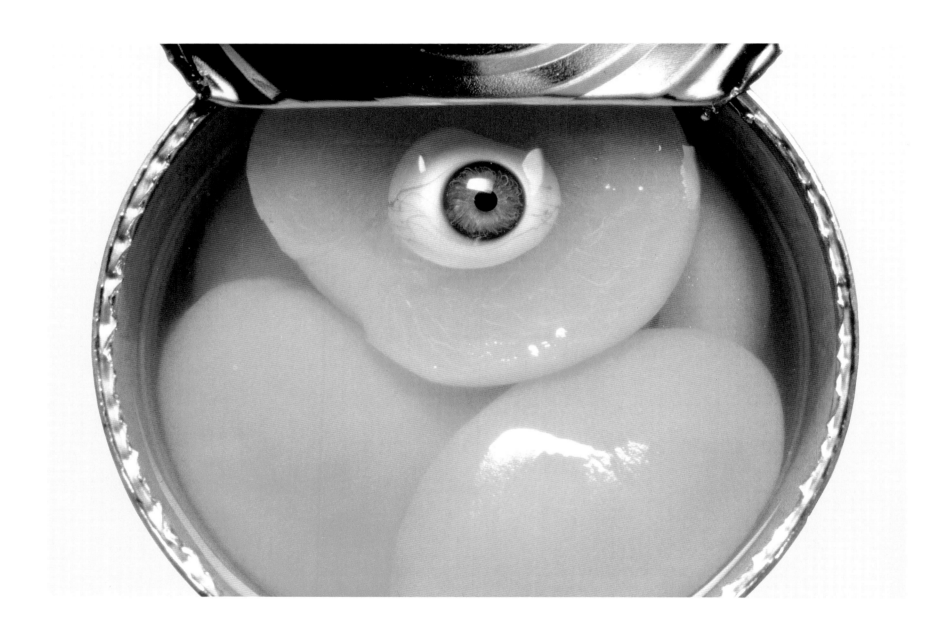

43. Eye to Eye

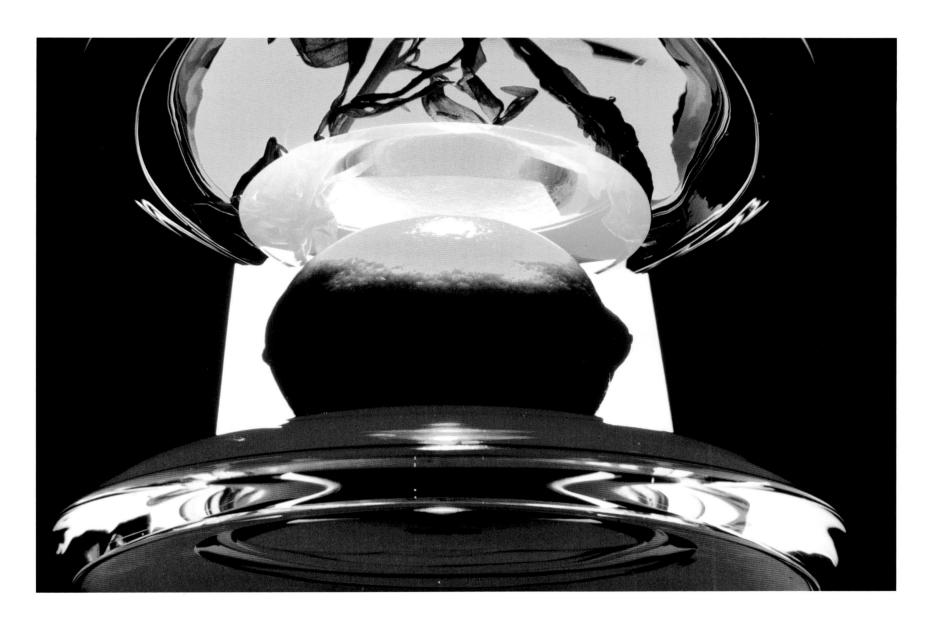

44. Dressings

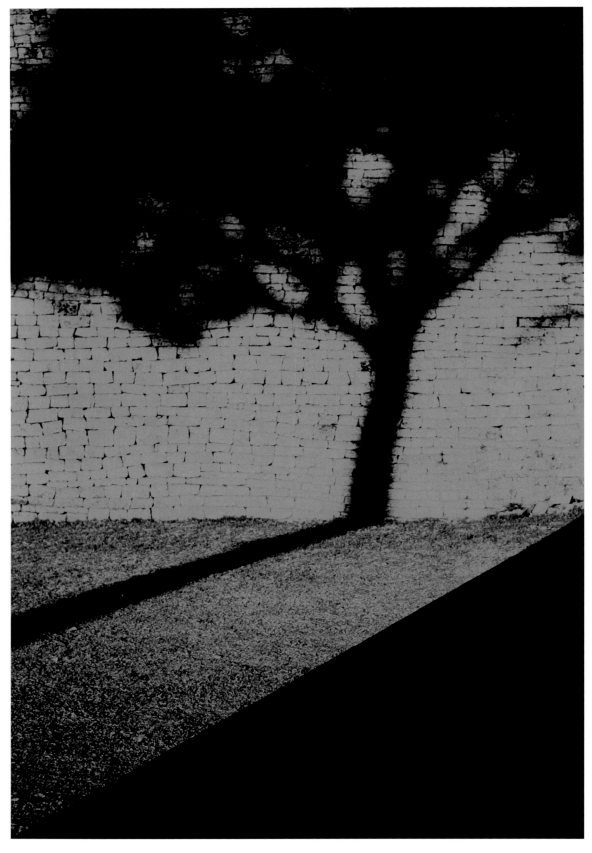

45. Zimbabwe Tree

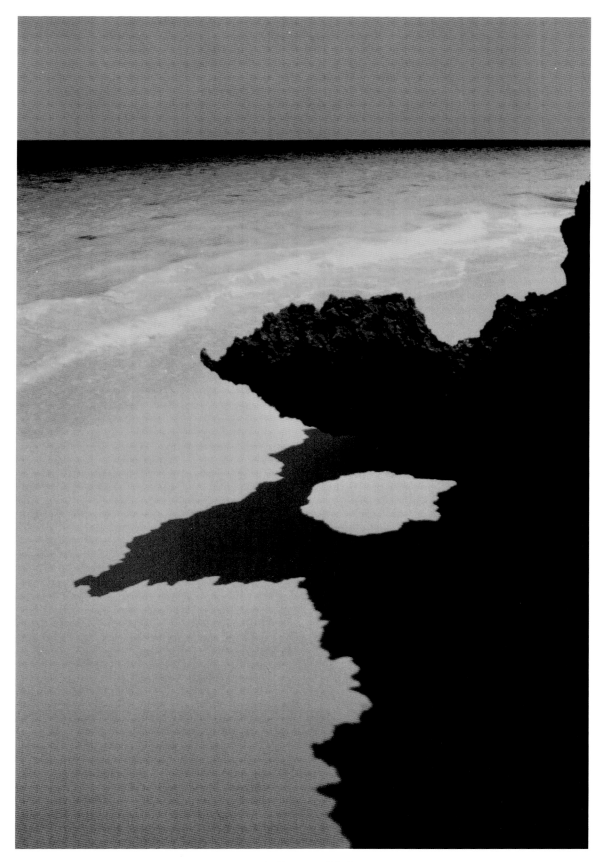

46. Cancun Bird

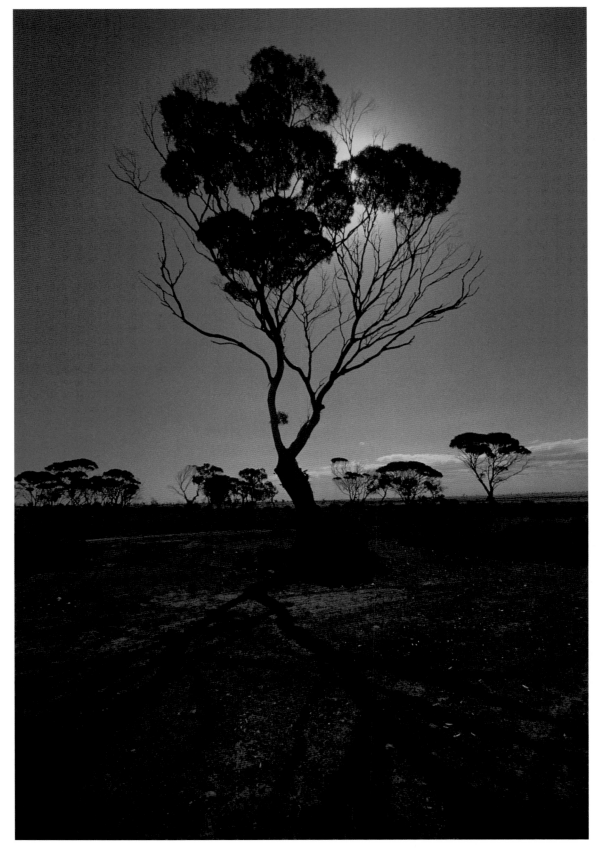

47. Nullarbor Trees 1

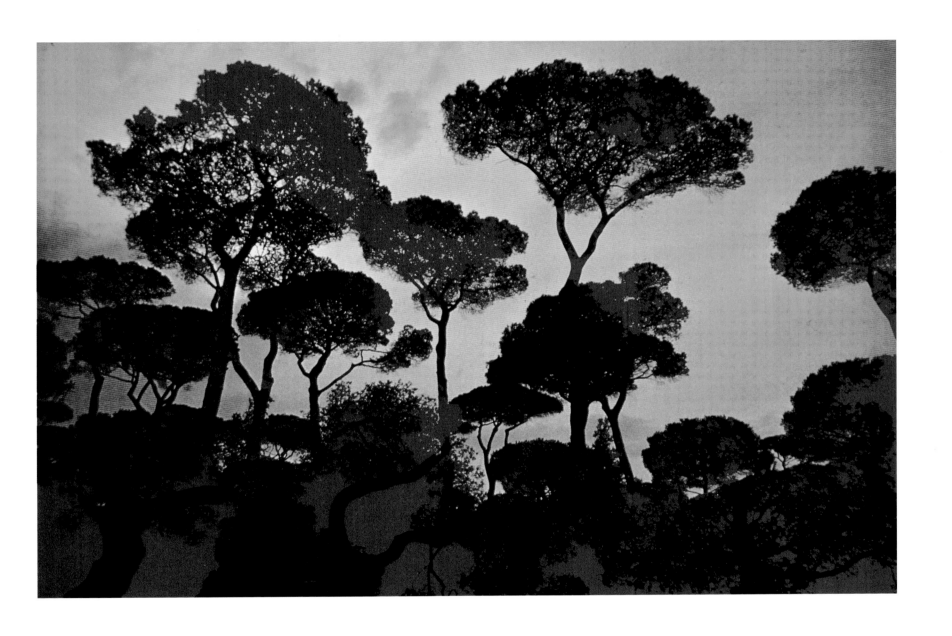

48. Umbrella Trees

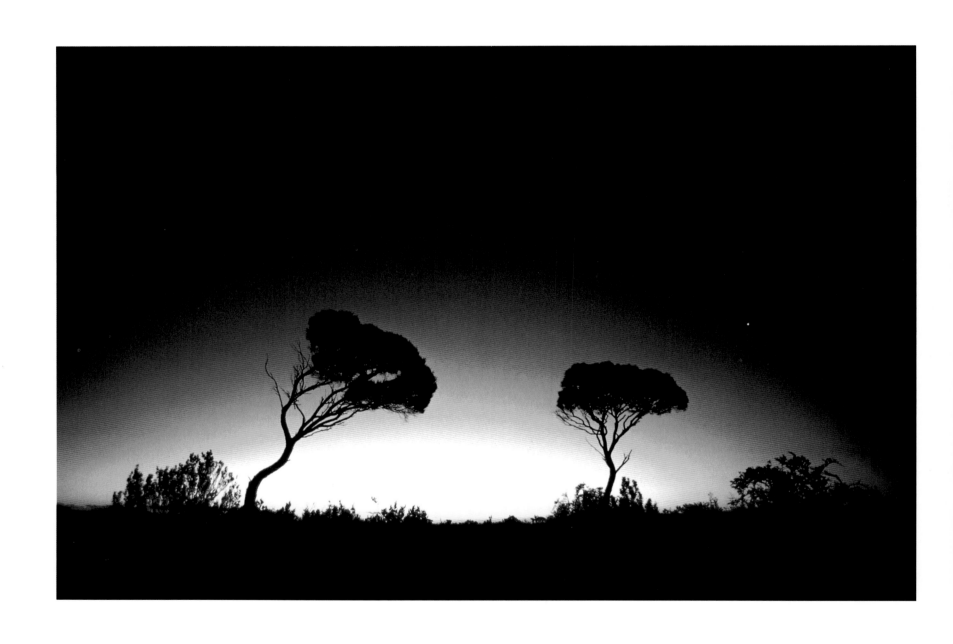

49. Nullarbor Trees 2

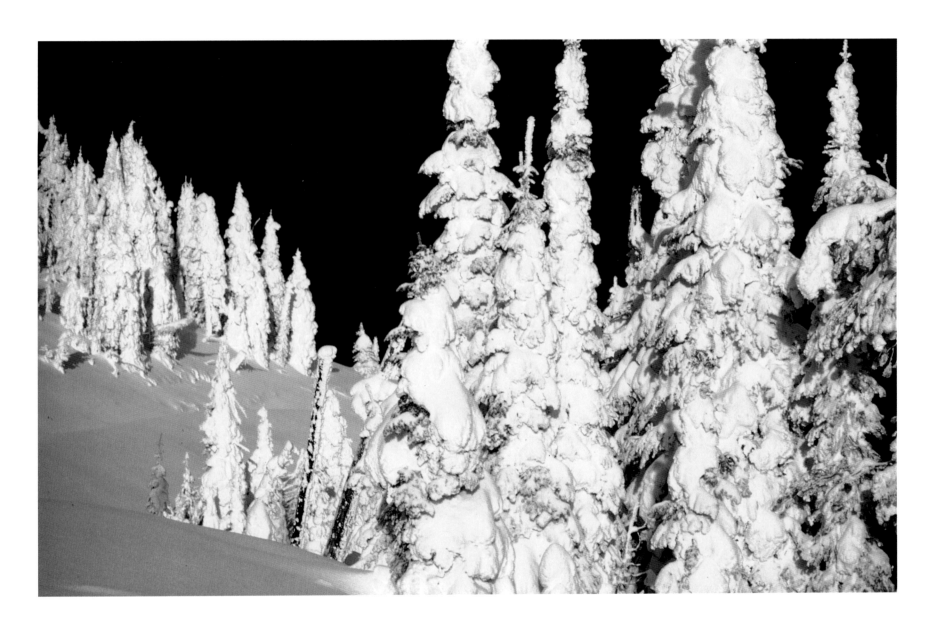

50. Winter Trees

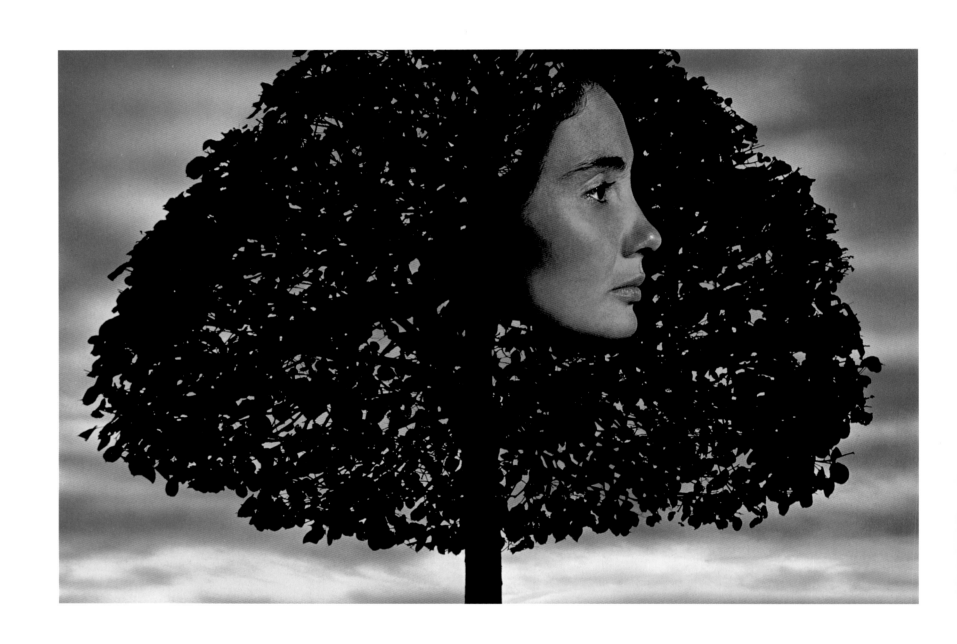

51. Daydreams of Magritte 2

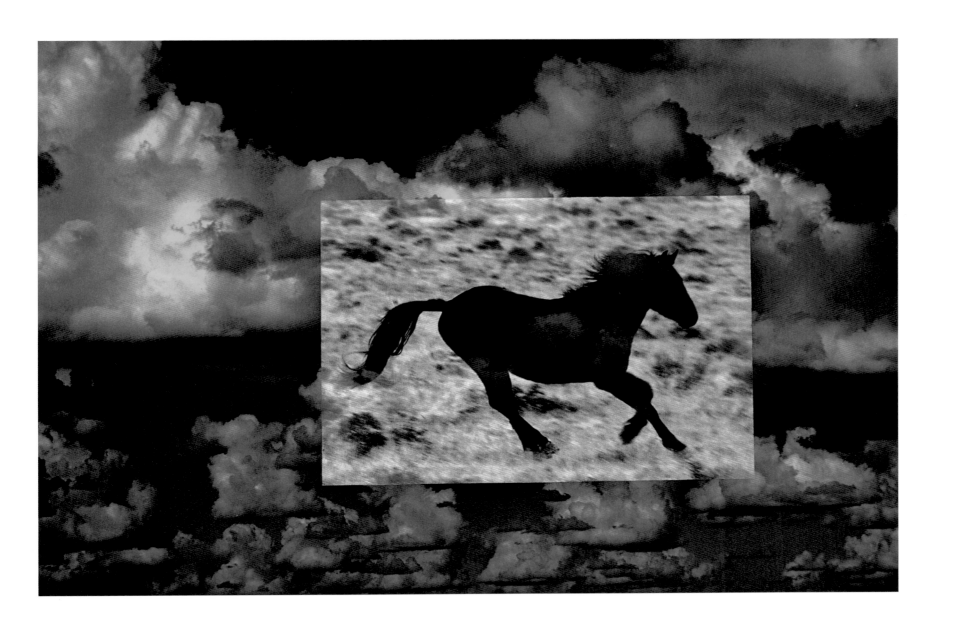

52. Horse in Clouds

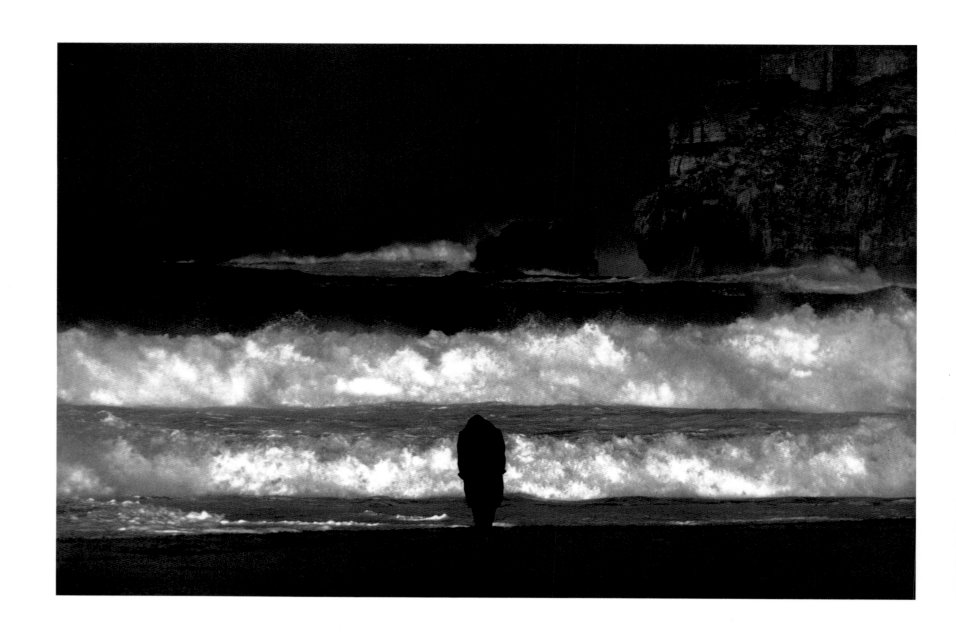

53. The Old Man and the Sea

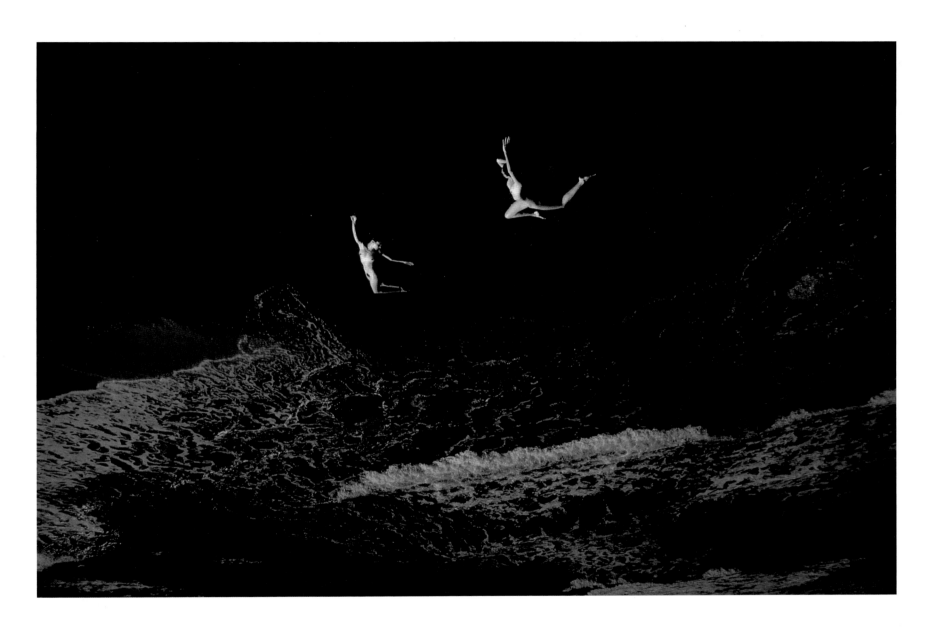

54. Flying Women

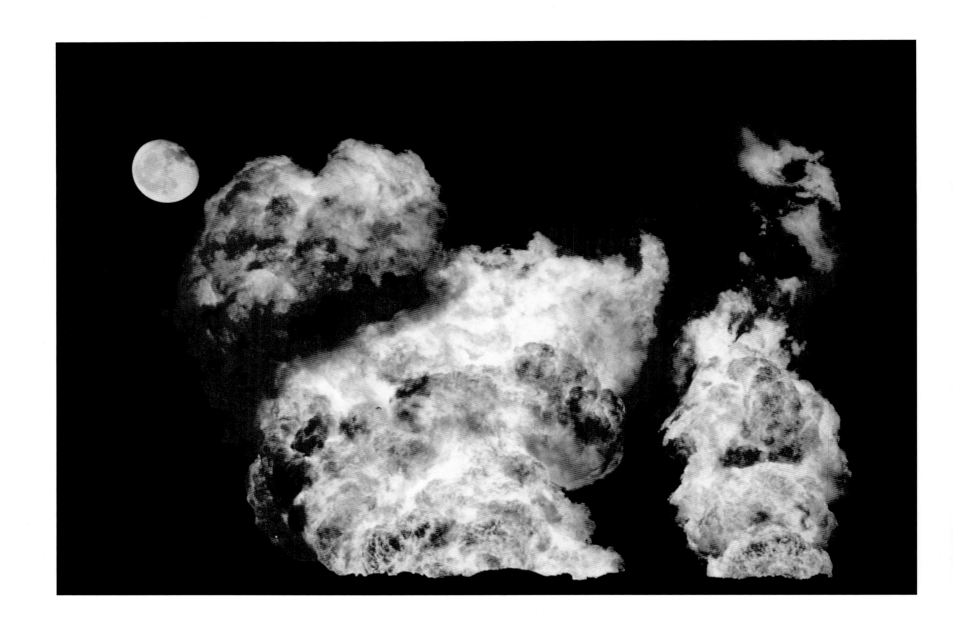

55. The Phoenix

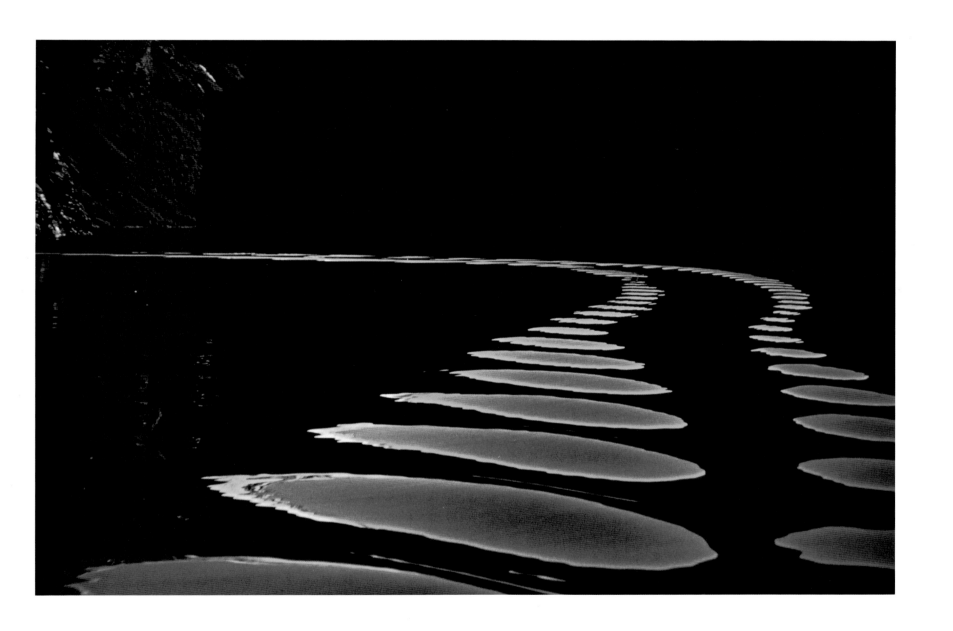

56. Boat Wake

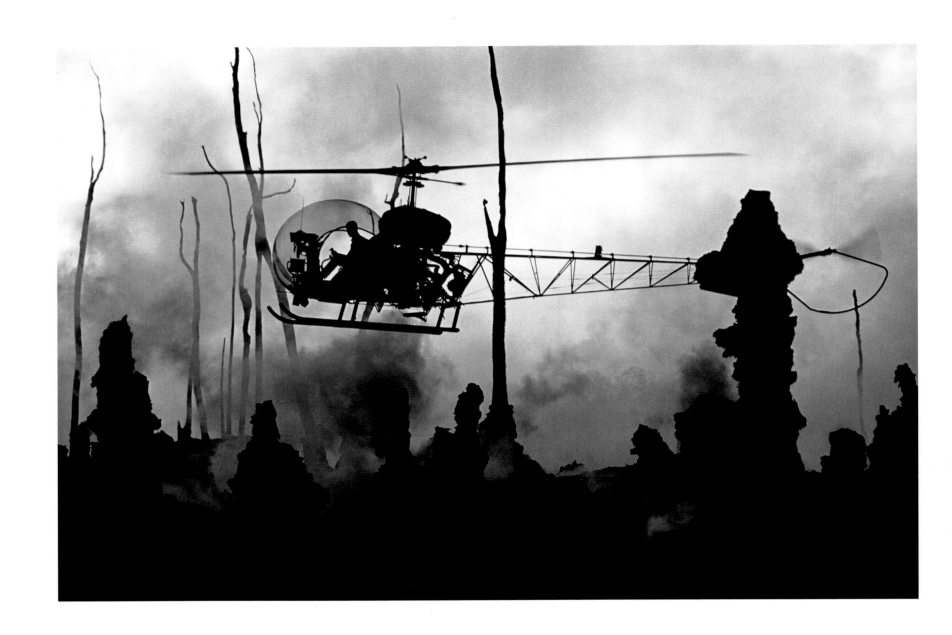

57. Descent

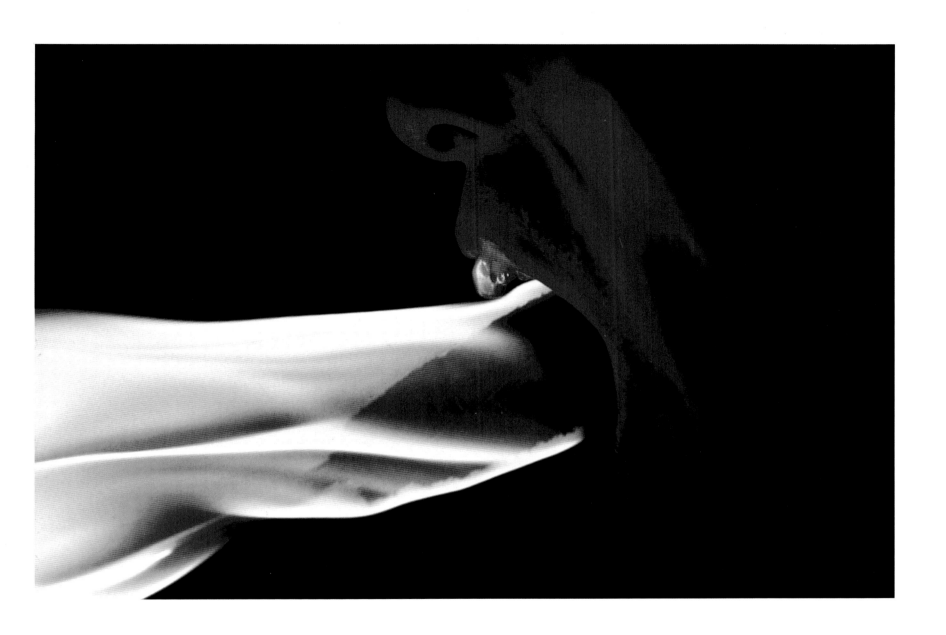

58. Fire-eater

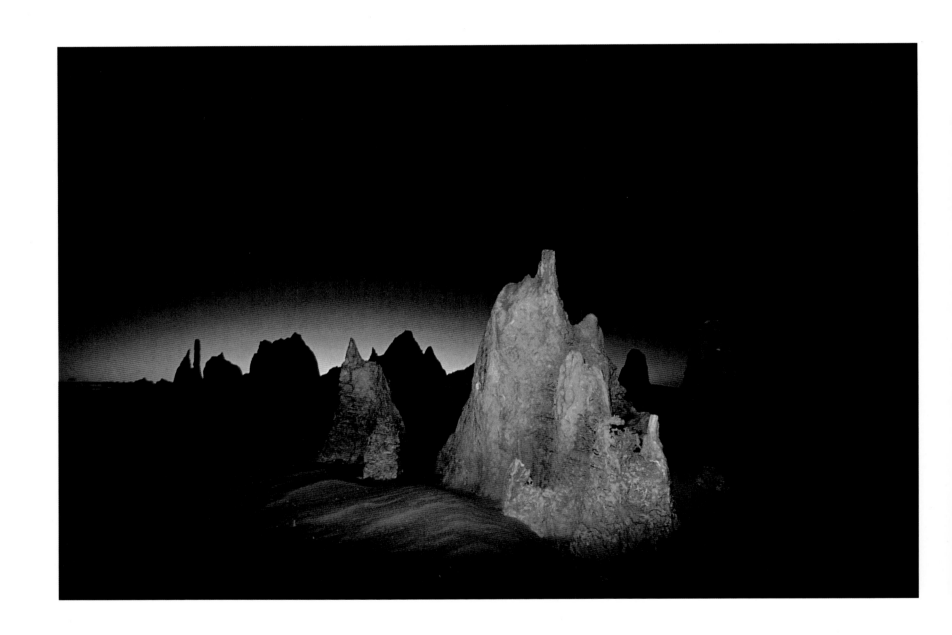

59. Pinnacles 2

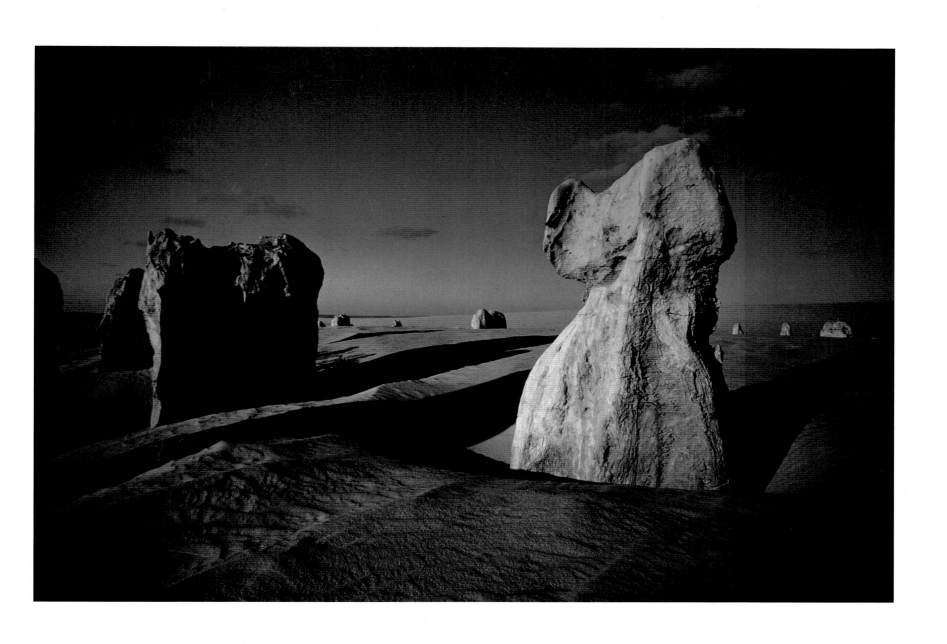

60. Pinnacles 1

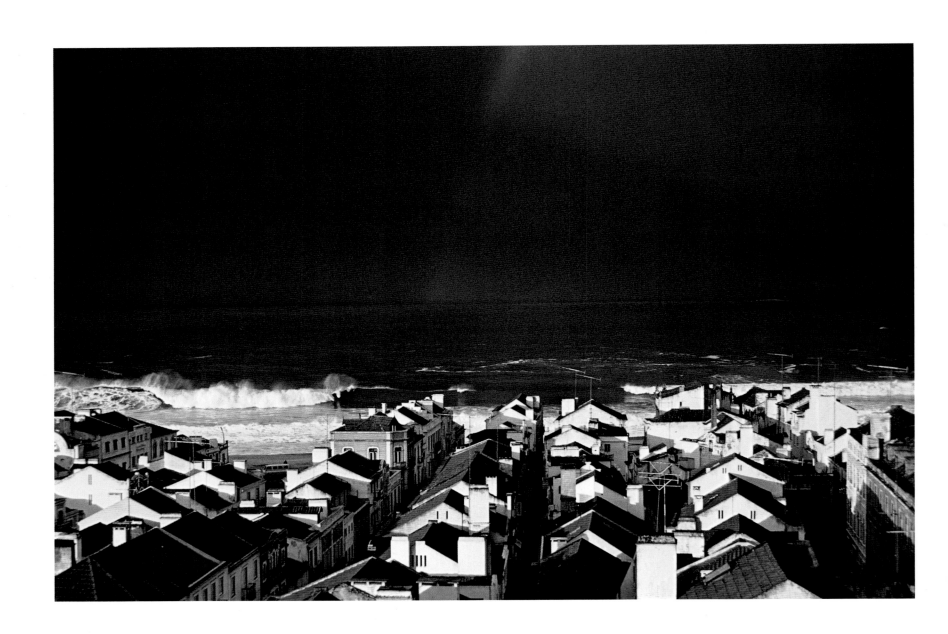

61. Nazaré

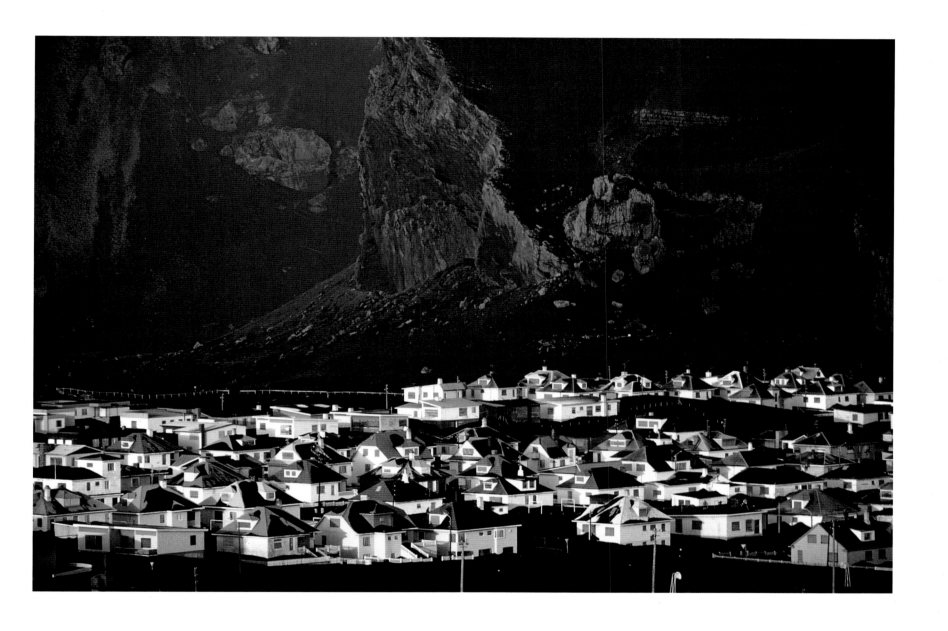

62. Black Snow

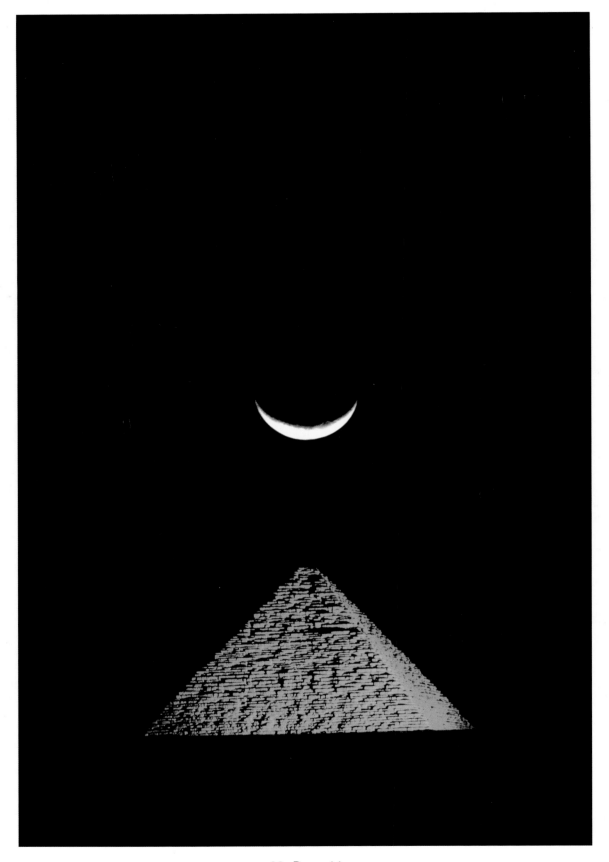

63. Pyramid

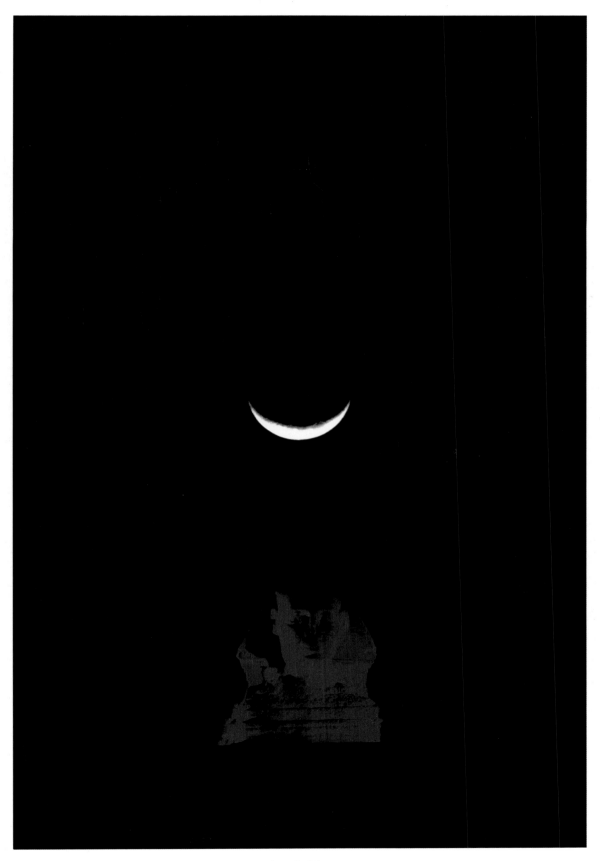

64. Sphinx

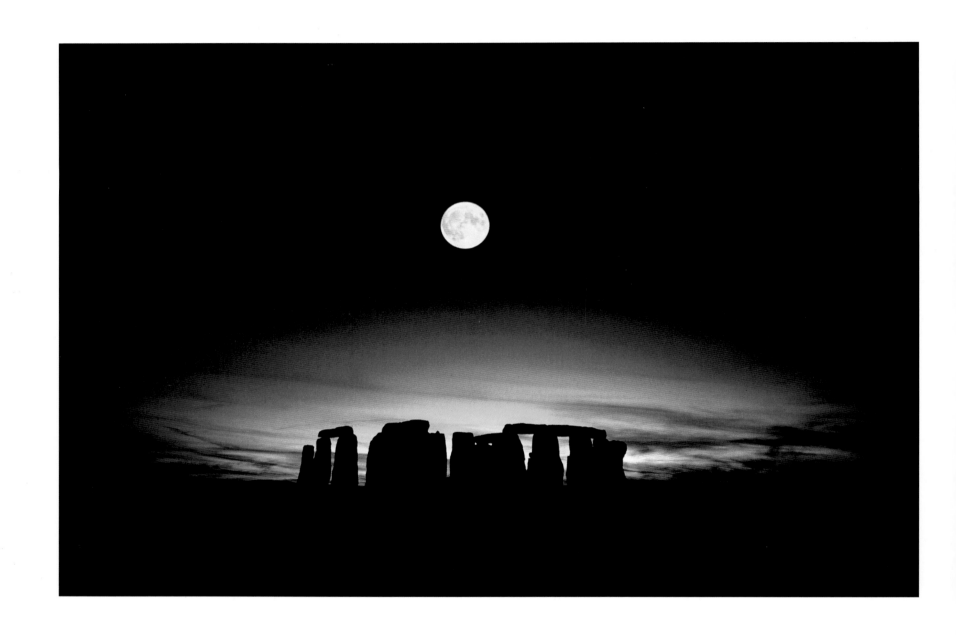

65. Stonehenge

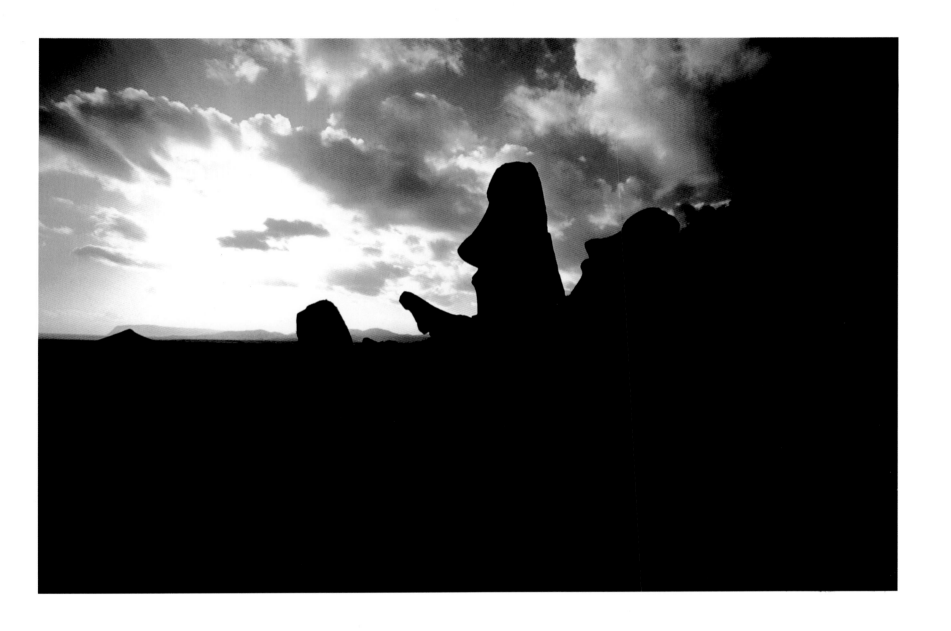

66. Easter Island

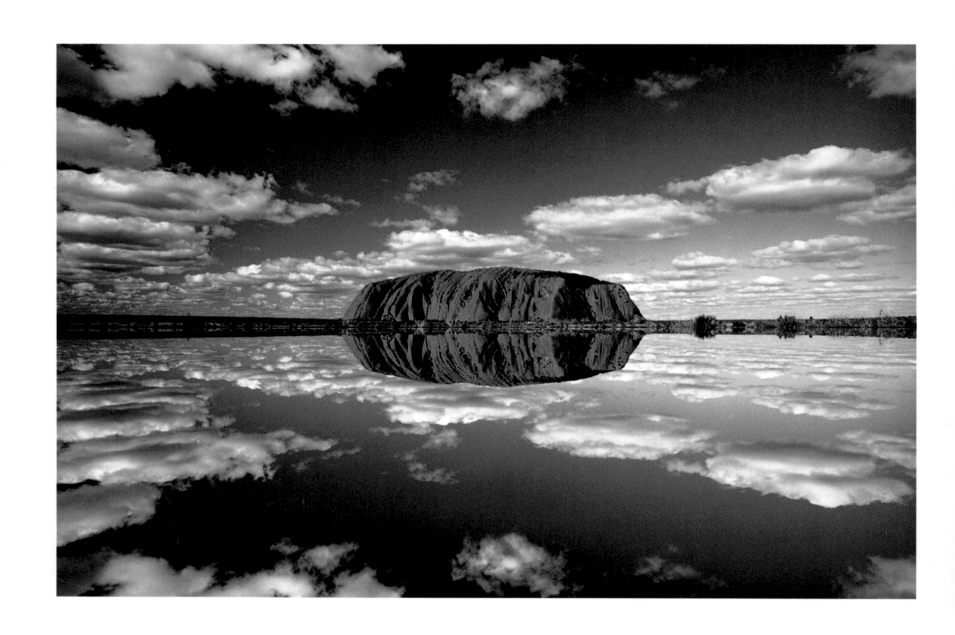

67. Ayers Rock 1

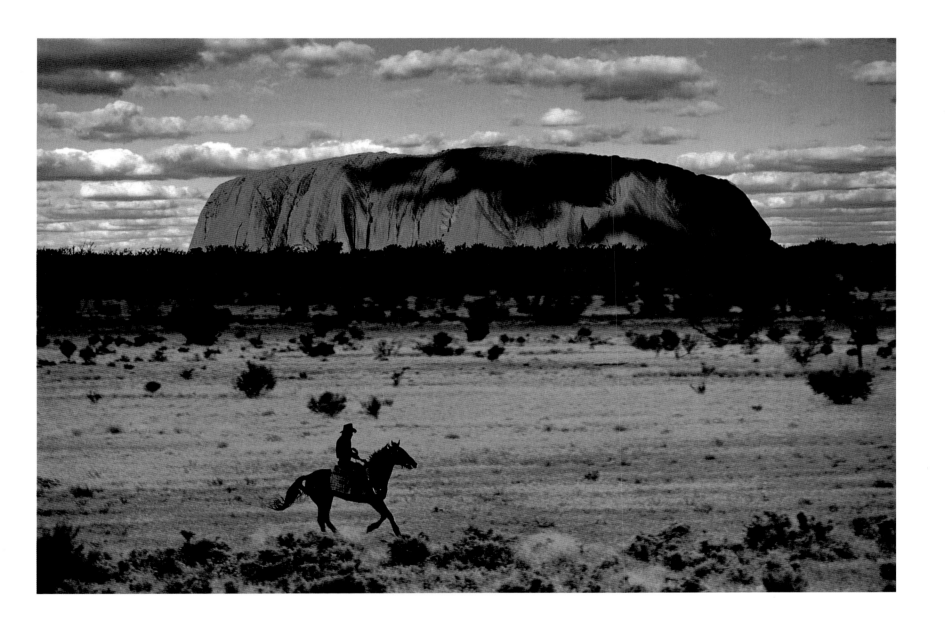

68. Ayers Rock 2

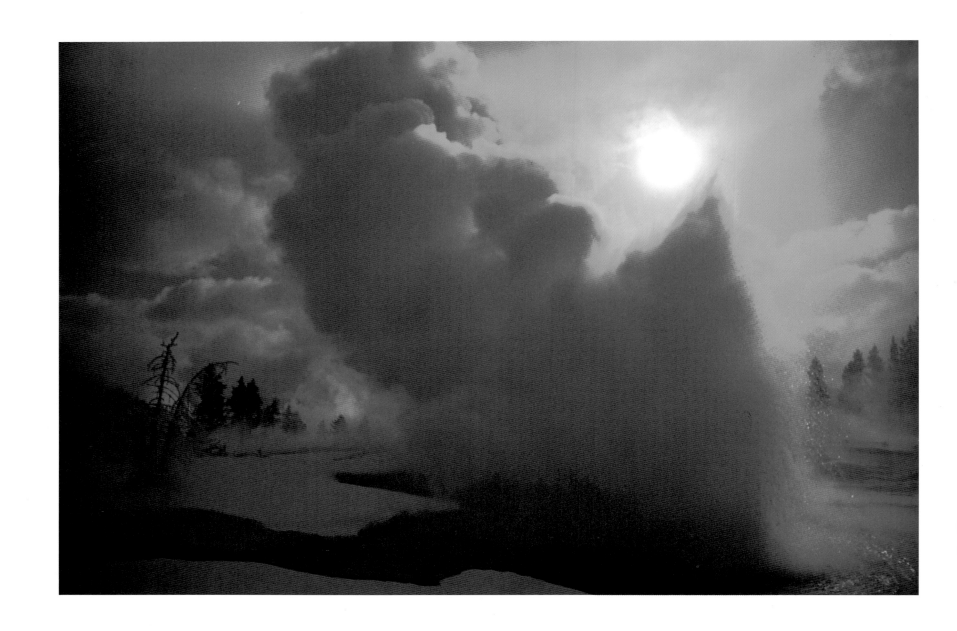

69. Old Faithful

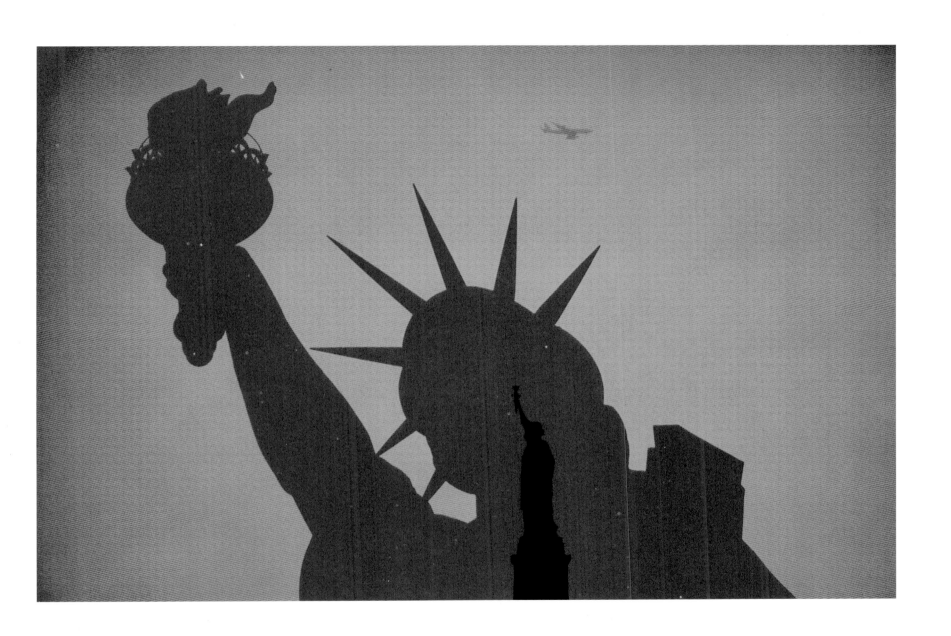

70. Liberty

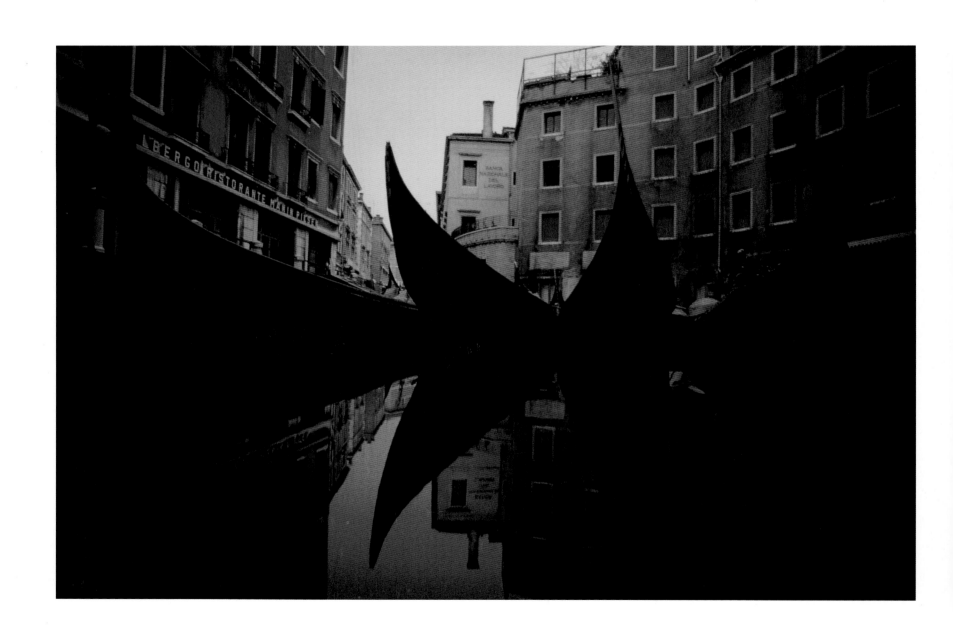

71. Venice

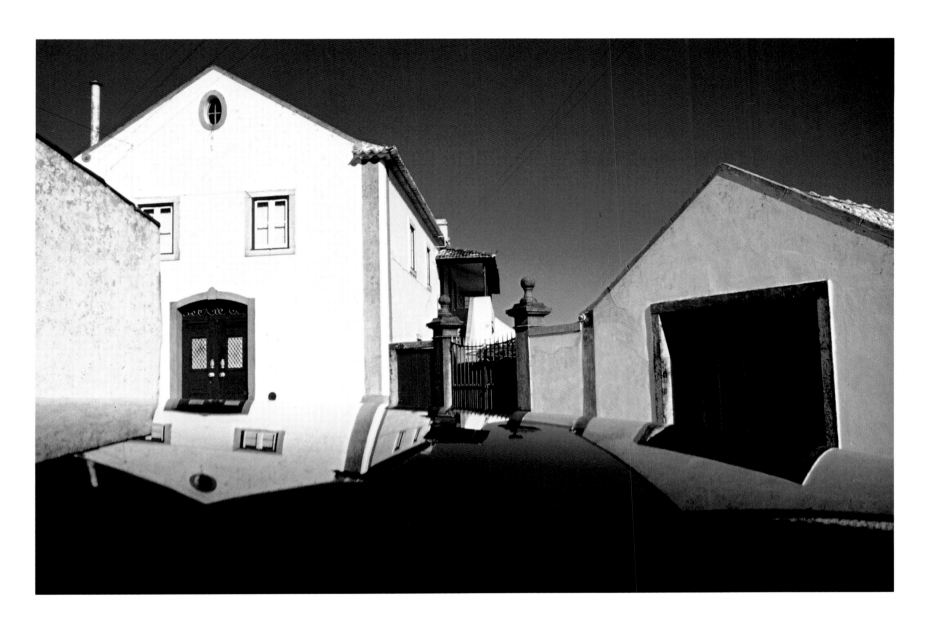

72. Portugal Reflection

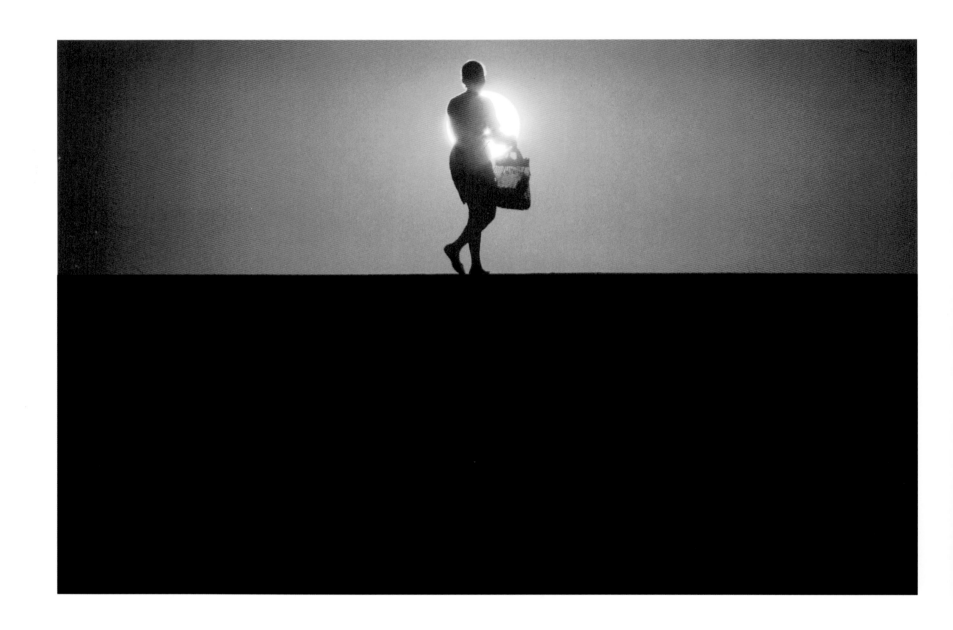

73. Shopping

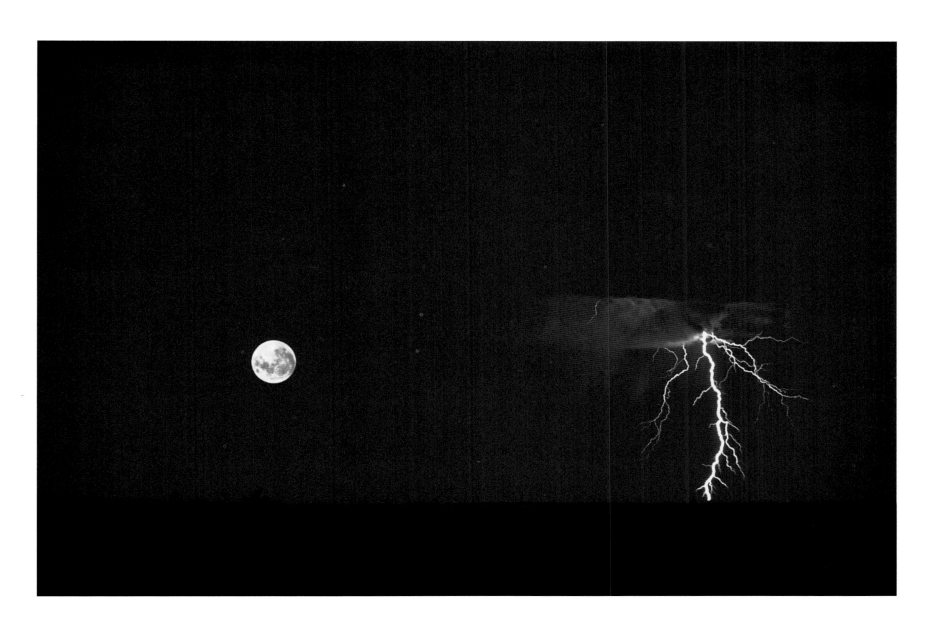

74. Lightning

75. Sand

76. Snow

77. Moon's Moon 3

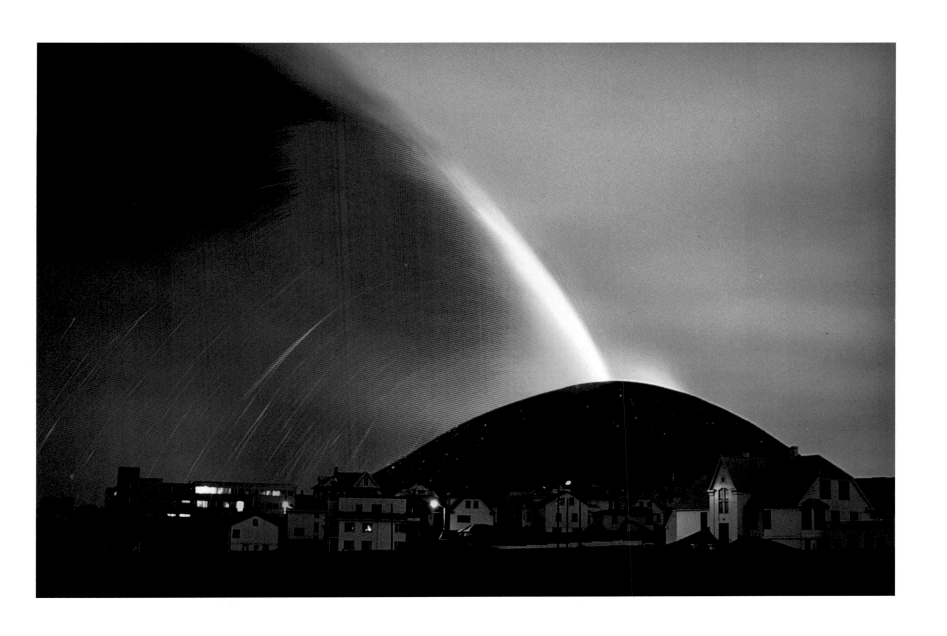

78. New Dawn

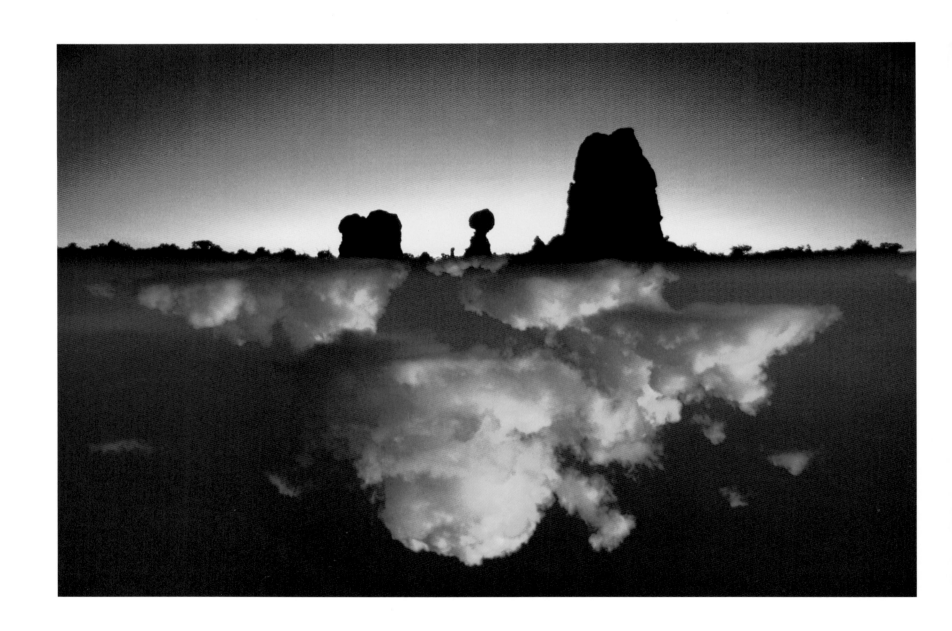

79. Shapes of Clouds to Come

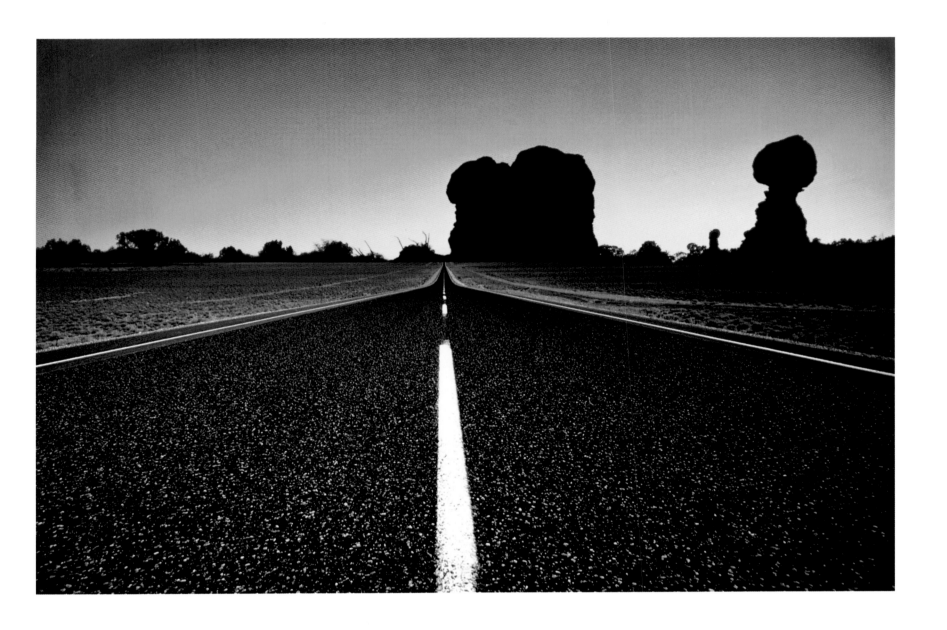

80. Shapes of Roads to Come

81. Wainscott

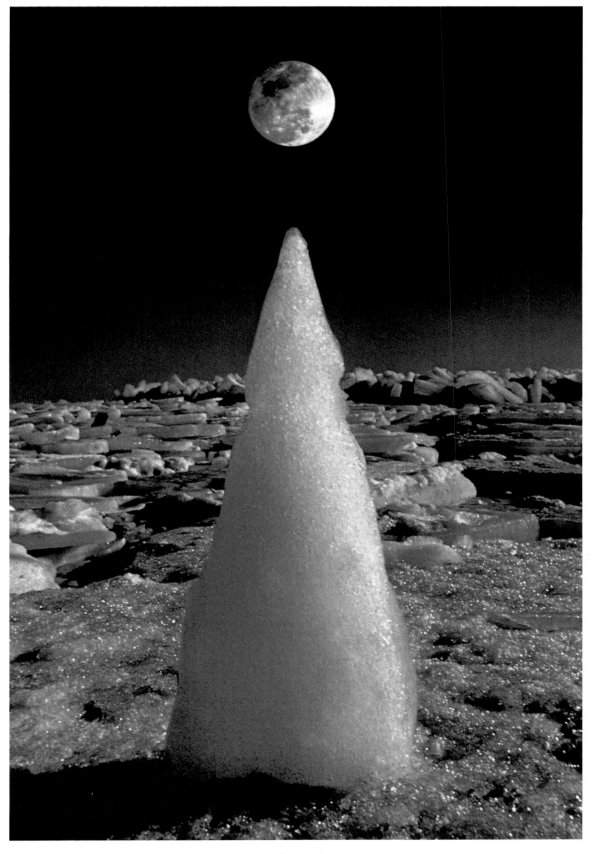

82. Antarctica

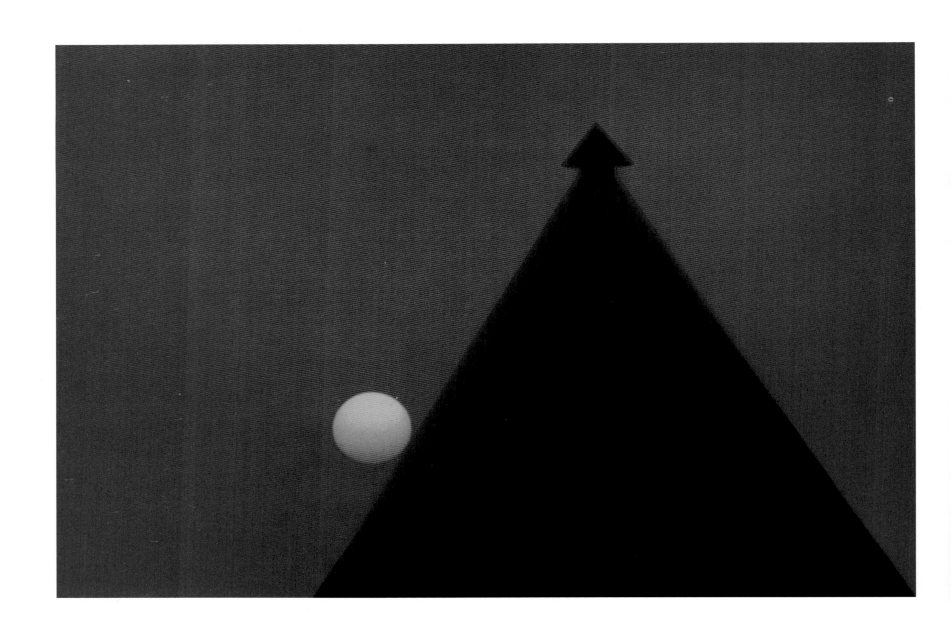

83. Rolling Ball

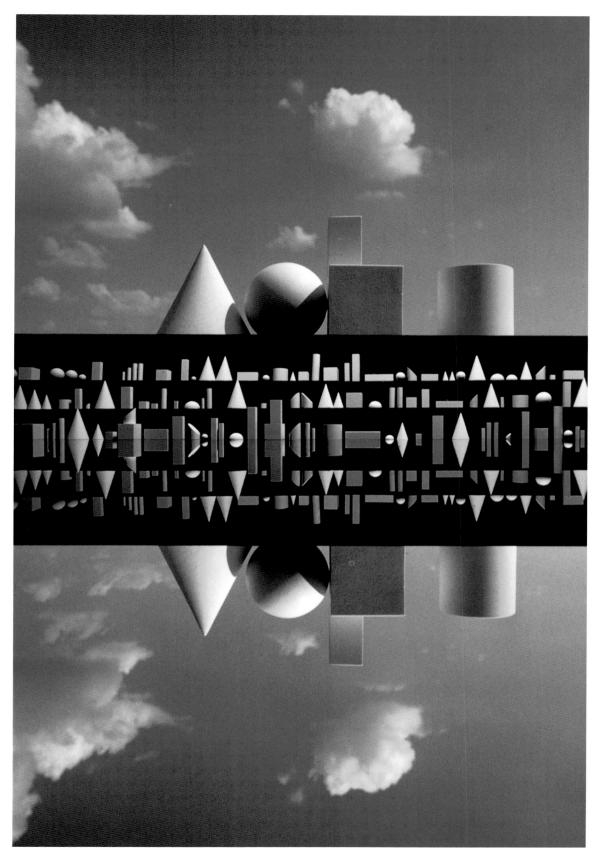

84. Shapes of Things to Come 1

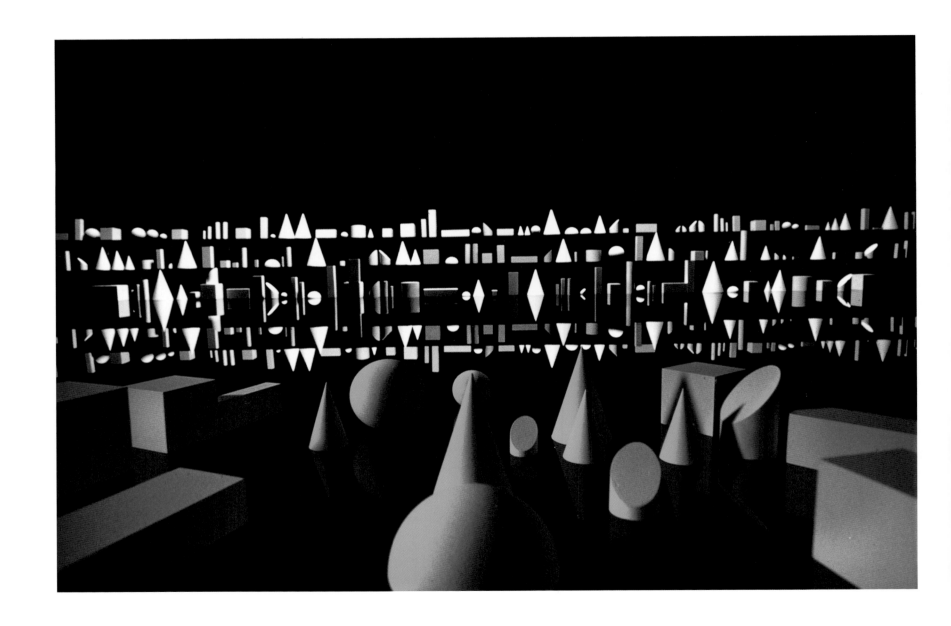

85. Shapes of Things to Come 2

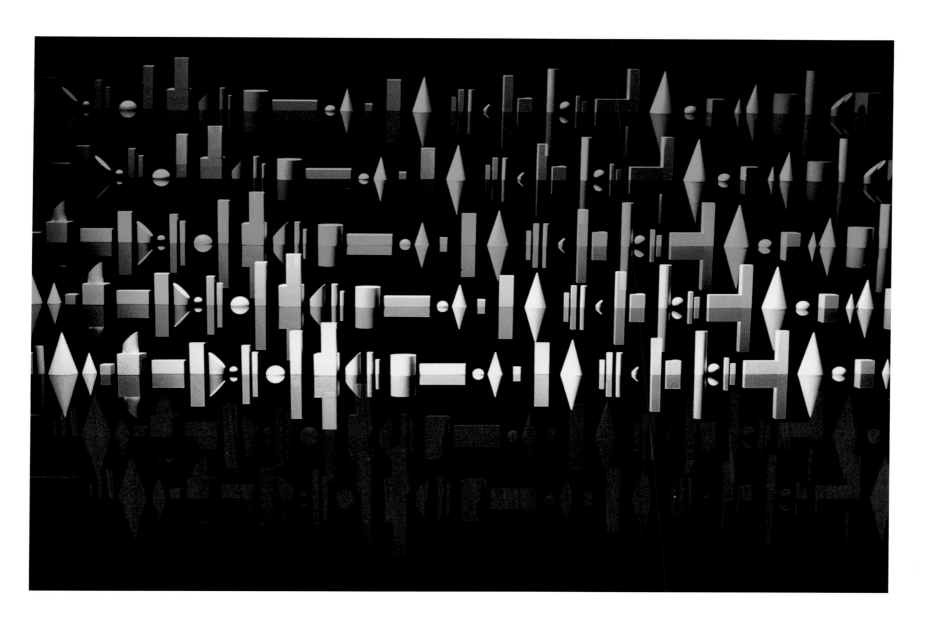

86. Progressive Geometric Shapes

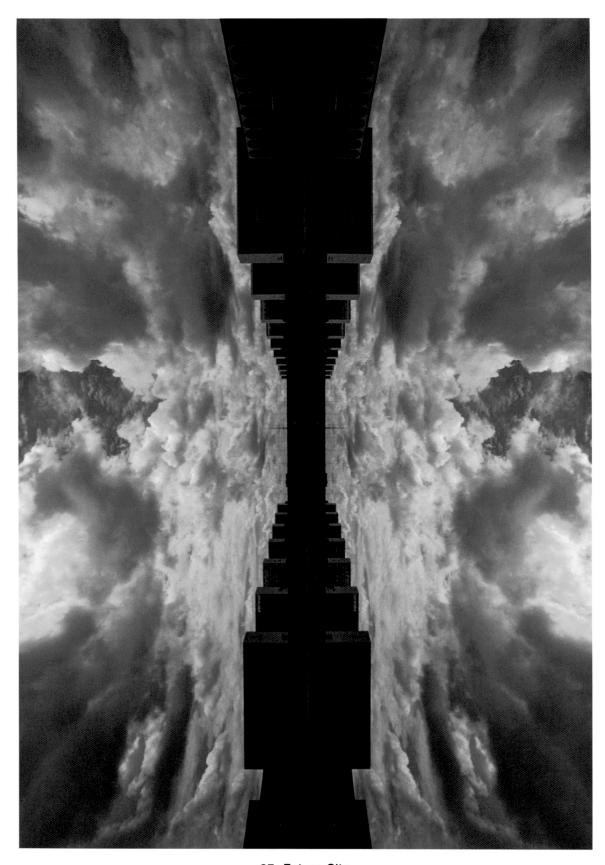

87. Future City

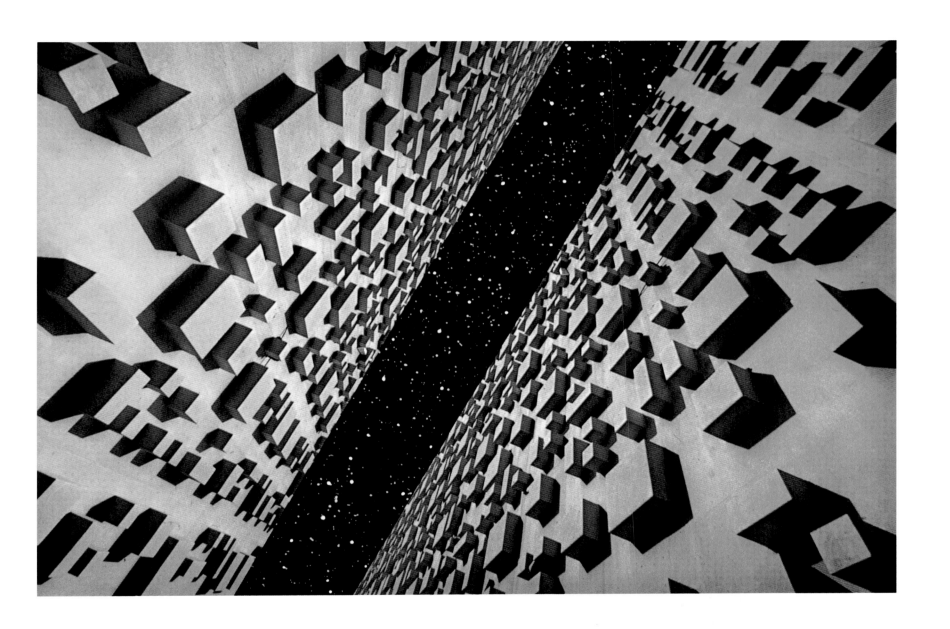

88. Brasília Walls

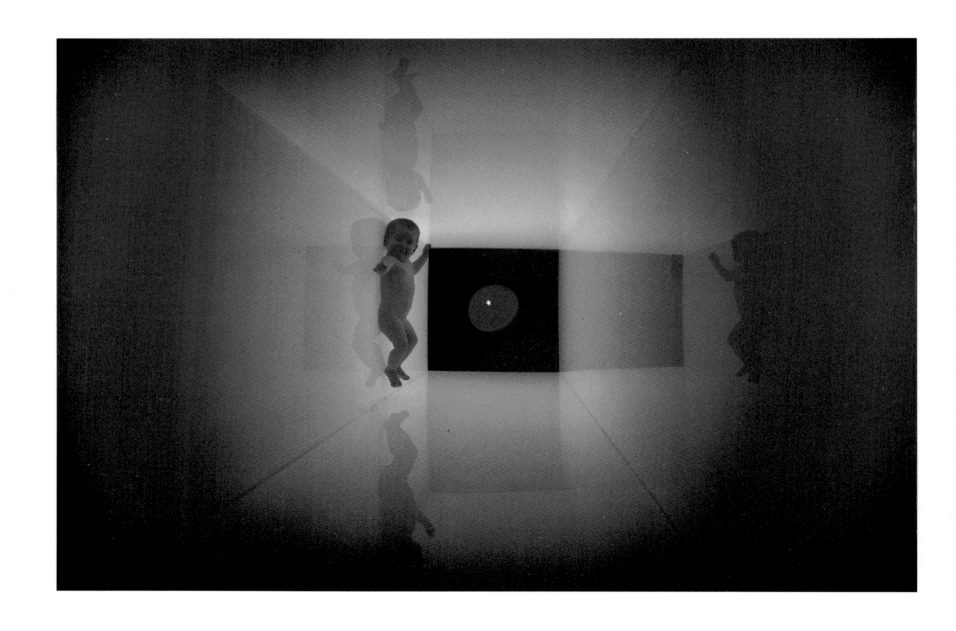

89. Baby in the Cube

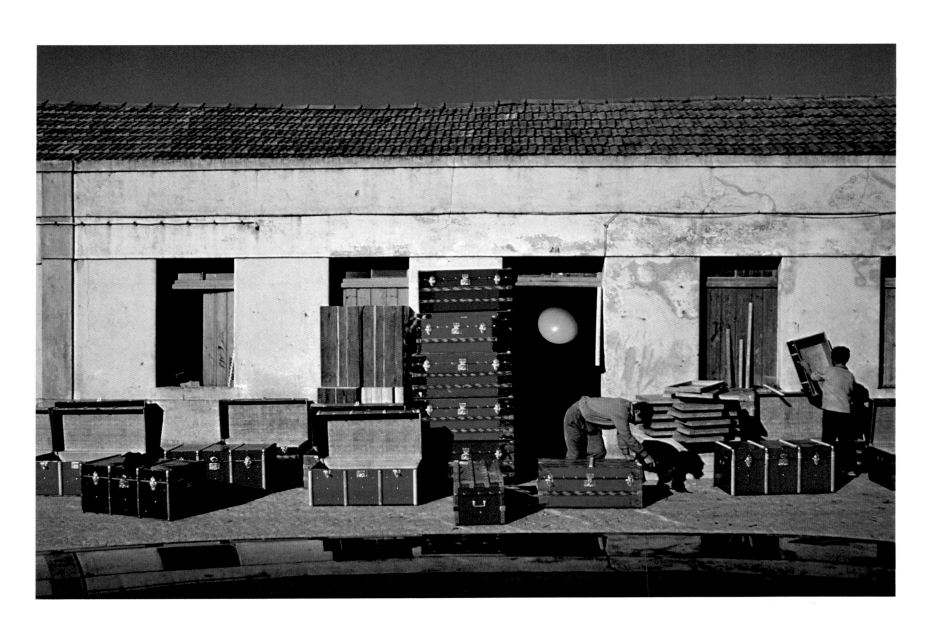

90. Doorway and the Sphere

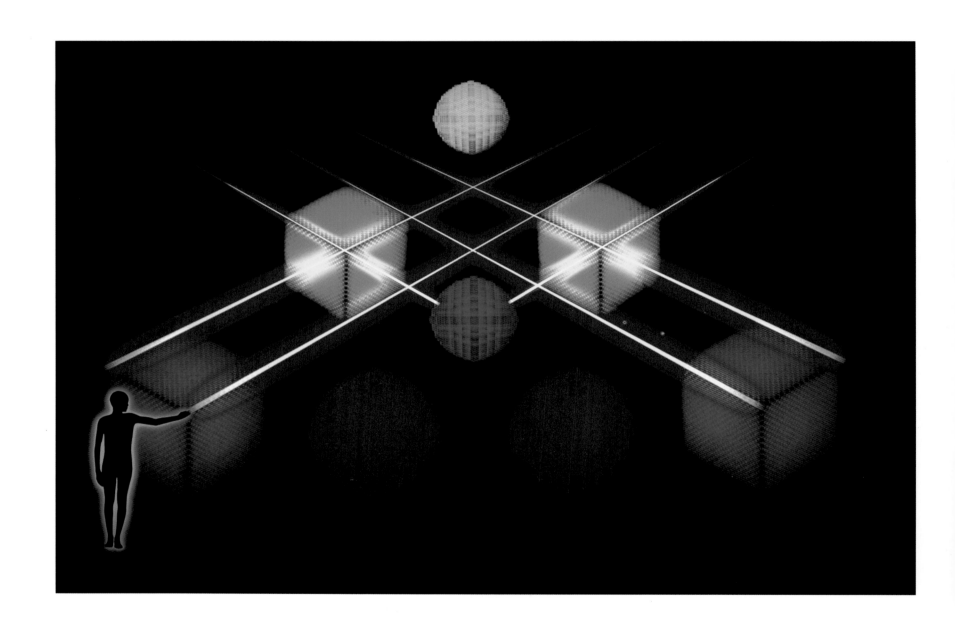

91. Pixelated Geometrics

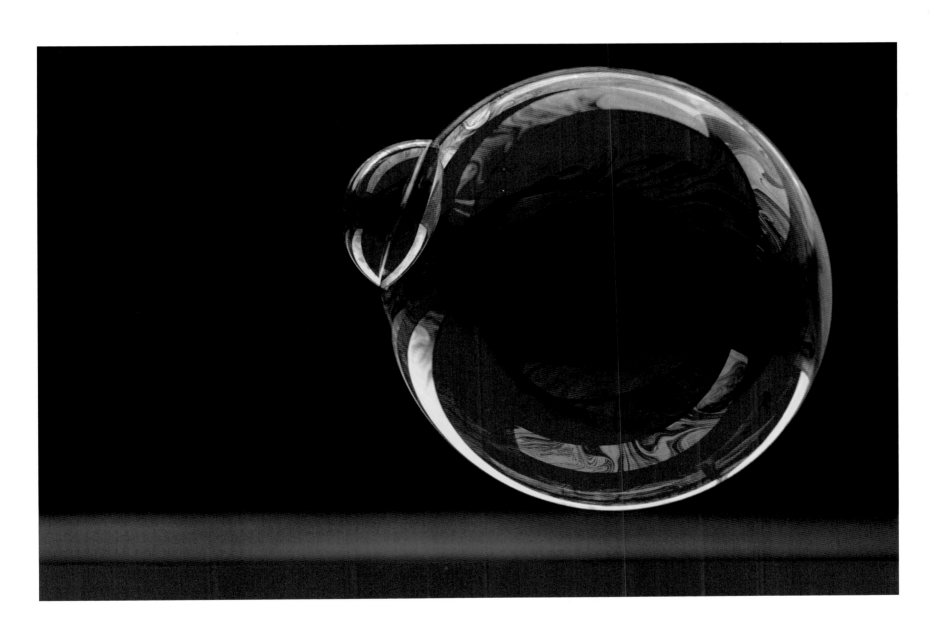

92. Bubble and Stripes

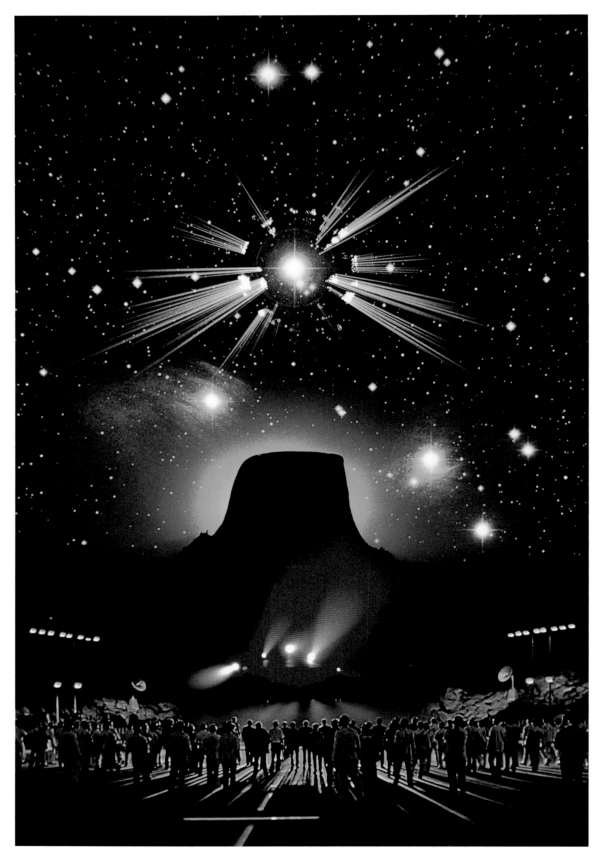

93. Close Encounters of the Third Kind

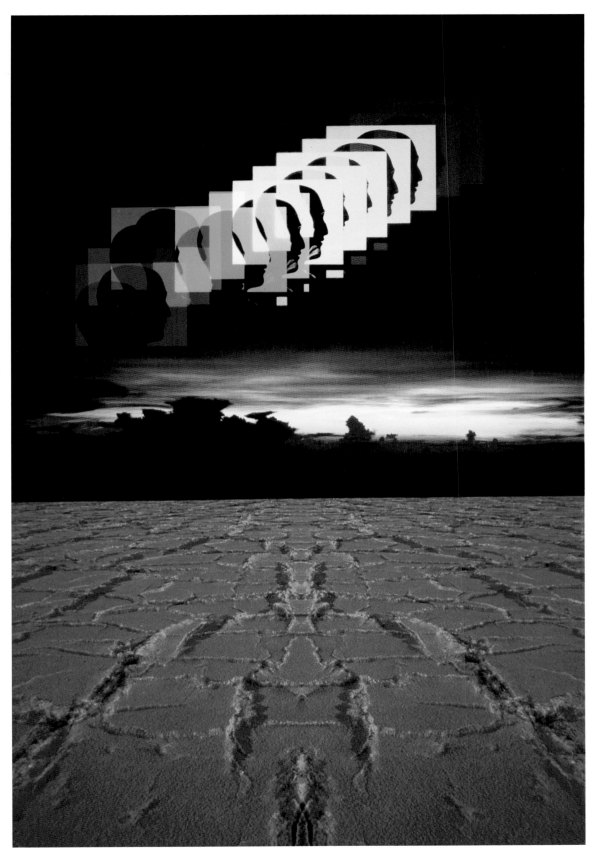

94. Plains and Progressive Man

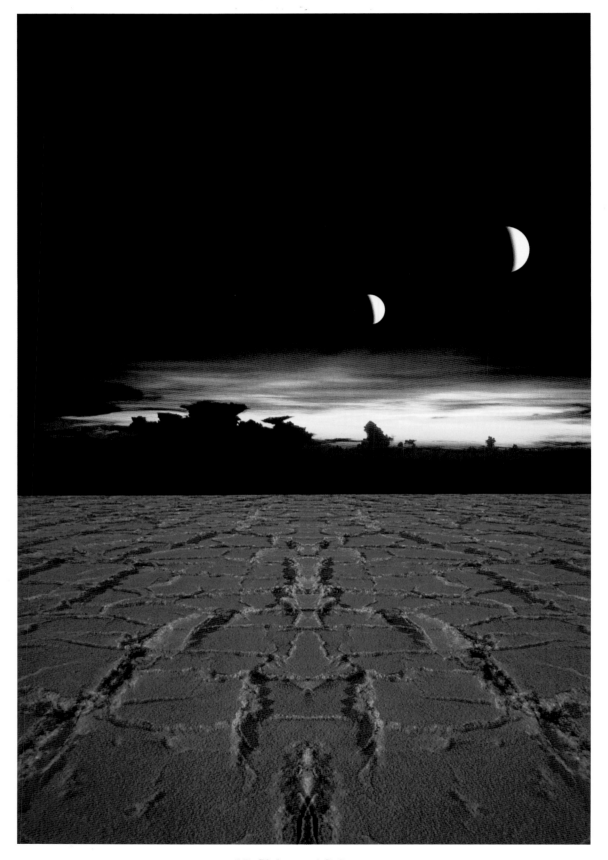

95. Plains and Spheres

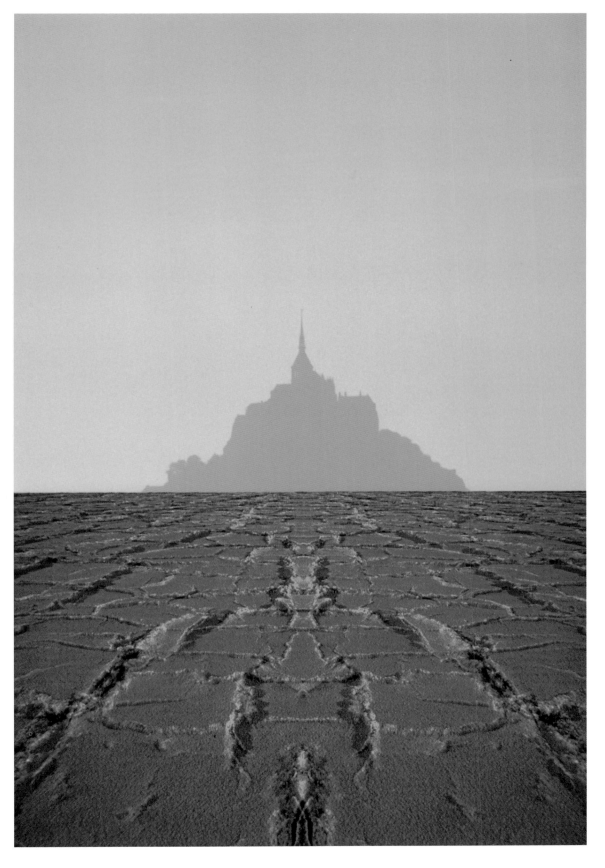

96. Plains and Mont St. Michel

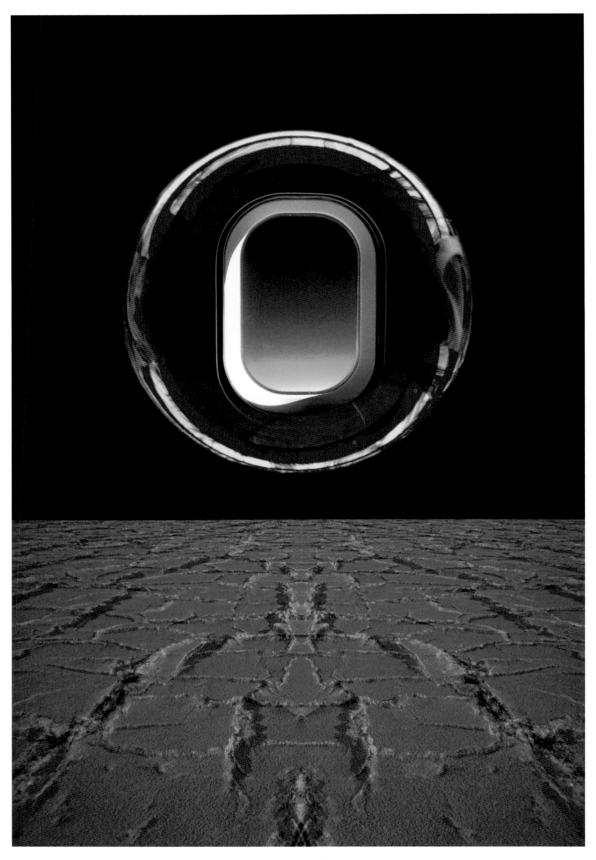

97. Plains and Window

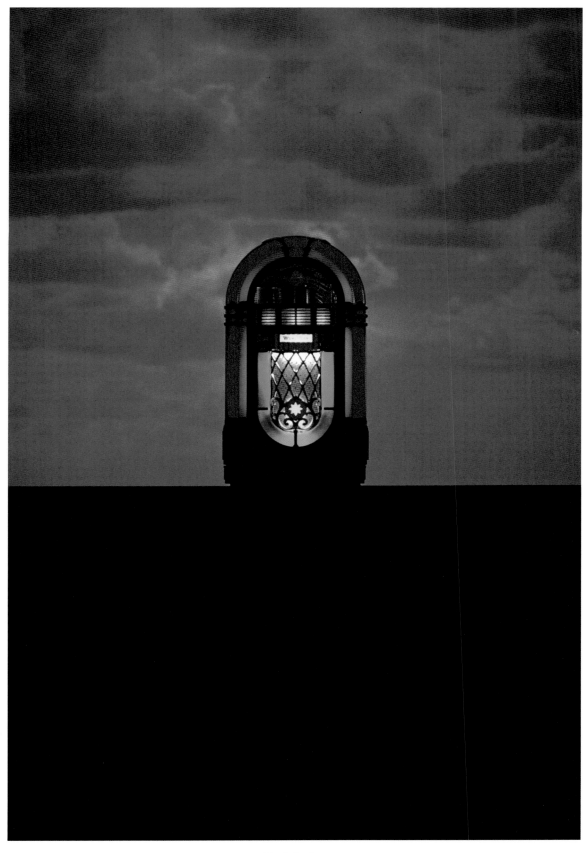

98. Jukebox

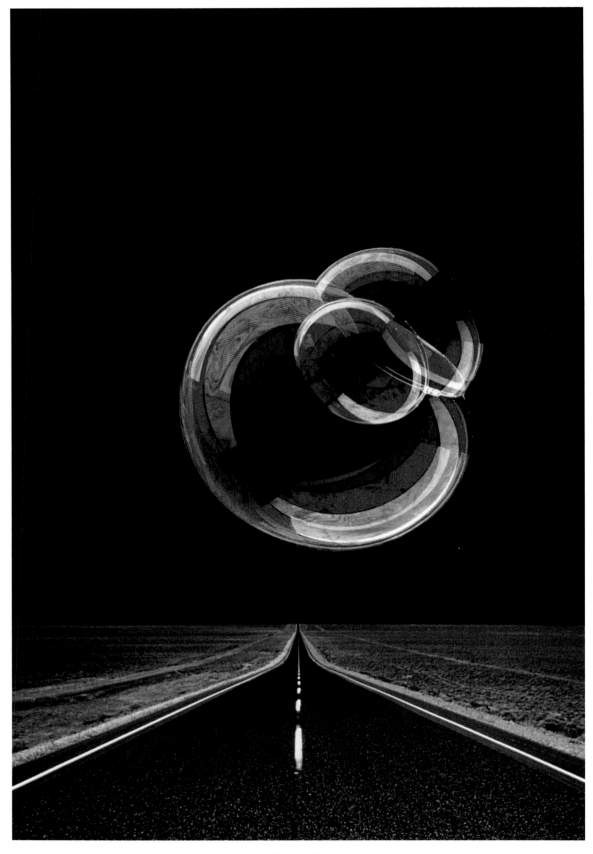

99. Future Road

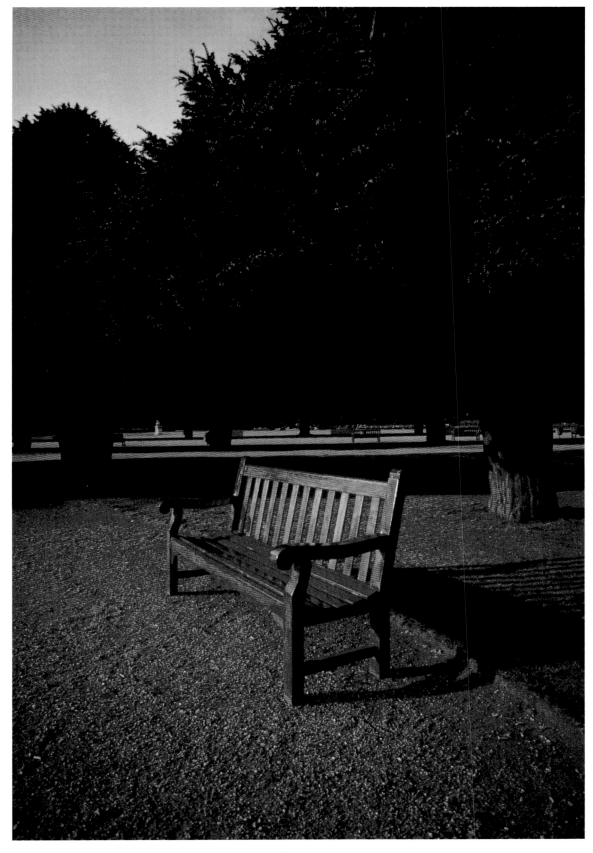

100. Benchmark

NOTES ON TECHNIQUE

I always like to start off a day knowing what I'm going for. What's my target, what's my subject? It gives me purpose when I wake up and say, "Today I'm going to photograph cheetah." Now on the way to photographing cheetah I might run into the most incredible thing and change my mind entirely. But it's nice to have a set idea when you're going out, rather than looking everywhere, hoping for wonderful pictures.

If I'm just going out to look (which I don't do often), I usually limit myself to two lenses—wide-angle and telephoto. That way I limit my thinking. Otherwise I'm asking myself a question every few seconds—am I thinking wide, am I thinking close? Usually it's good to say, all right, we'll do landscapes today and use a long lens, a 300 or 400mm. If you do this, you'll make your eye look only at distant things. This will concentrate your attention, discipline it. If you try to think of every lens in the book you'll drive yourself crazy.

All my life I've used nothing but Nikon cameras and lenses. I have no hesitation about endorsing them. I started with Nikon SP rangefinder cameras, moved to the single-lens reflex F when it arrived, on to the F2, and now I use the automatic F3. All my cameras are motorized. I use lenses from 15mm to 400mm.

For me, the original piece of film is like a black-and-white negative. It's the starting point for an image, not the final result. My finished work is always second generation. All of it has been put through an optical printer, essentially a machine that enables me to rephotograph original transparencies. (Camera-produced originals are kept in a bank vault for safety.)

Rather than using duplicating films I reprint from Kodachrome onto Kodachrome. I started shooting with the original ASA 10 film and now exclusively use Kodachrome 25. It's my film of choice in the studio or on location because of its capability for saturating colors and holding sharpness.

But making duplicates is not the point of all this. With the optical printer significant changes to the image can be made. Colors can be enhanced or new colors introduced; contrast can be increased or subdued, and different images or elements can be constructed. Various techniques perfected over the years enable me to dodge and crop the image as well. My original setup was a Repronar with a Nikon body and a 55mm Micro-Nikkor lens. Currently I use a specially designed machine that holds 35mm Kodachrome in long rolls; the lens is an 80mm El-Nikkor enlarging lens. Dichroic filtration can be dialed in. The optical printer allows precise alignment of the final image regardless of the number of original elements used in production.

Color photography to me is about mood and feeling. If you can control the colors, you can create the mood. In the early days I used filters all the time, but eventually I found out that you couldn't go back to neutral. Now I may add a filter on location but I'll also shoot the subject as it is, which provides me the option to change color later. I use a polarizing filter less these days because I find that with my techniques the film blocks up heavily. If you use a polarizer you will get a black or a very dark sky when going to the second generation. (Note: The effect of a polarizing filter cannot be added in the reprinting process.)

Many of the images I've made have come about through cross-fertilization with the ideas of other people. Although we all like to say our work is truly original, I find often that this is not true. A lot of people contribute to helping me make images, and sometimes they take my ideas further than I could have imagined them myself.

Pete Turner
New York, 1986

 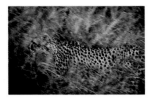 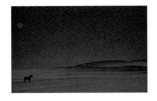 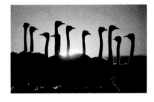 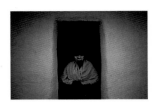

1. **2.** **3.** **4.** **5.**

1. Giraffe Kenya, 1964. In the Amboseli National Park, which is really an enormous, flat salt pan, you feel as if you can see forever. I thought it would be fun to photograph some giraffes while we raced alongside them in our Land Rovers. By the use of walkie-talkies we were able to herd animals in groups. I loved the way their feet came together; you can see that in this particular image. *Nikon F, 105mm Nikkor.*

2. Cheetah Kenya, 1970. *Cheetah* was also done in the Amboseli Park. I had been on the lookout for cheetah, and all of a sudden we found one. He was just walking slowly. I could see coming up ahead some beautiful bamboo bushes. I thought if I used a slow shutter speed, about 1/15th of a second, it would give me a wonderful feeling of motion: I could blur the bamboo and still get the feeling of this cat going through it, almost stalking. I used a CC30G filter to amplify the foliage. *Nikon F, 200mm Nikkor.*

3. Blue Horse Montana, 1961. I saw a barren landscape with very subtle hills in the background, all covered with snow, and a beautiful black horse, almost like a silhouette. It was one of those overcast days when everything was gray. I knew right away it needed a color. The horse is a lonely horse; he's a blue horse. If I had filled the frame by using a 300mm lens it would be an entirely different type of horse. The idea was to bring this horse down to a very small shape and give it a delicate quality, an overall blue feeling. A CC100B filter gave me the color that I liked. *Nikon F, 105mm Nikkor.*

4. Necking South Africa, 1970. Here I've gone in very tight, which amplifies the necks and gives these birds a surreal feeling. I think if I had pulled back from the ostriches, made them the same size as the giraffe or the horse, I would have lost the effect. I like silhouettes, they're always strong. *Nikon camera, 300mm Nikkor.*

5. Pondo Woman South Africa, 1970. Pondo is the name of a tribe in the Transkei. This woman was leaning out her doorway. I asked permission and she agreed to pose for me. I'm not very good at intruding in people's lives, and the way I work I really don't have to. I can ask for cooperation. (The white on the woman's face is a cosmetic decoration.) *Nikon camera, 55mm Micro-Nikkor.*

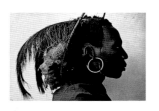 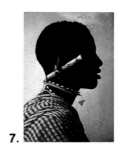 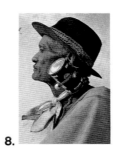 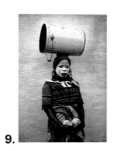 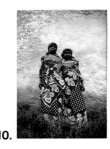

6. **7.** **8.** **9.** **10.**

6. Electric Earring

7. Cigar Earring

8. Can Earring Kenya, 1970. These photographs are based on an idea of Harold Hayes. Harold had mentioned that he was quite intrigued by Maasai earrings. In the small town of Namanga, I asked one of the Maasai chiefs to gather members of the tribe so that I could make portraits. I found a place where I could get north light. The session lasted two or three hours; I photographed perhaps twenty different people. Here we have the most interesting of the people I photographed. *Electric Earring* is wearing the traditional Maasai headdress with feathers, but in his ear is a copper transmission wire that has been stripped of insulation. *Cigar Earring* wears a tin cigar container that I got from Harold. I thought it would make an interesting shape. I guess I'm not a purist in terms of reality. I make pictures. They're a combination of "made" and "found" images. I go after my prey, I stalk it, I think about it, and then I might change a few things. The fact that the cigar can was so shiny and bright meant that I could drop the exposure to some degree. I turned the man so the lighting was from the back and the front was in shadow. The other man (*Can Earring*) was facing the light. *Nikon F, 55mm Micro-Nikkor (three photographs).*

9. Coconut Woman Mozambique, 1970. This is a "found" picture. I was driving one day and I saw a beautiful woman walking along with a can on her head. I asked the driver, who was also a guide, to ask the woman if she would pose for me. She agreed and I asked her to walk to a colored wall I had seen about a block away. I shot several rolls and then paid the woman for her time. I always offer to pay people when I photograph them. I make a point of that. *Nikon camera, 105mm Nikkor.*

10. Two Women Mozambique, 1970. I asked these women to pose for me because I loved the colors of their dresses and the contrasting textures of the wall. Unlike Mexico, or places where the walls are very garish, Mozambique walls often have a beautiful, muted color. *Nikon camera, 105mm Nikkor.*

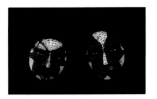

11.

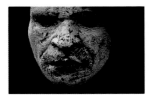

12.

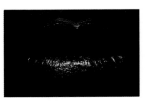

13.

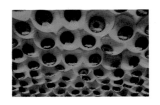

14.

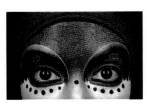

15.

11. Twins New Guinea, 1967. The graphics and the mood of this photograph have been enhanced by the lack of background. Lit by daylight, it was shot so that only the remarkable painted faces and bright colors stand out. I've tried different magnifications of the image in which the heads become very large and there's hardly any background, and I've reduced it to very tiny faces in a wall of black. I've also tried to move them apart left and right, but I go always back to the framing that I started with. It seemed right at the time and it still is. Black is a wonderful element to work against. *Nikon camera, 55mm Micro-Nikkor.*

12. White Man New Guinea, 1967. I had been to New Guinea on an assignment for *Esquire* magazine in 1963 and I decided to go back. I asked the editors of *Look* magazine if they would be willing for me to do portraits. When I returned with the pictures, they decided that the photographs were too tight on the faces and didn't show enough of the environment. Nothing was published, but I ended up with some wonderful pictures. *Nikon camera, 55mm Micro-Nikkor.*

13. Hot Lips New York, 1966. There was a point in my life when I was sick of seeing those very slick advertisements for women's makeup. I wanted to achieve a savage look, so I hired a theatrical makeup man. I said, "I want the reddest red you can make." I don't know what he used. The photograph was lit with a point-source strobe rather than a bank light or natural north light. *Nikon F, 55mm Micro-Nikkor.*

14. Soft Room New York, 1968. If you look at a false eye it follows you; it looks at you. I thought it would be great if I could do a still life of false eyes. My wife, Reine, found a place where we could get 200 of them. I started laying them down on a table, designing, just for fun. I used the north light in my Carnegie Hall studio and stopped the 20mm lens all the way down for maximum depth-of-field. I made a Polaroid. (They're great because you can see your picture in different ways.) As soon as I looked at the Polaroid print upside down I said, "Oh, this is for me!" It looked like a ceiling, a "wet" ceiling with eyeballs. *Nikon camera, 20mm Nikkor, CC100B filter.*

15. Reflections New York, 1970. This is an experiment in the sense that I wanted to see what happens to the human eye when you don't see a photographer's umbrella reflecting in it. The eye is not only a mirror of the soul, it's also a mirror of the photographer's studio, or the photographer. Peggy Moffit's face was lit through a 4' by 8' sheet of milky plastic with two strobe heads on either side of the camera. A hole was cut in the center of the plastic for the lens. A 36" circle of black paper was centered on the outside of the lens hole, creating the black circle reflection on the eye. *Nikon camera, 105mm Nikkor.*

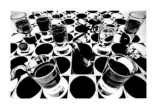 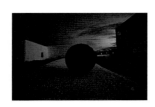 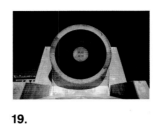

16. **17.** **18.** **19.** **20.**

16. Chessboard New York, 1966. I love *Chessboard* because of the colors and the perspective. My natural vision is more attuned to the 20mm lens than the so-called normal 50mm. I tend to have good peripheral vision and the 20mm is one of my favorites of all the lenses. I love it because you can get great depth-of-field. You can do things with the 20mm (on 35mm film) that view cameras can't even touch. I usually stop down to minimum aperture, then I use the depth-of-field preview and focus by eye on what I feel is the optimum point. *Nikon F, 20mm Nikkor. Kodachrome Type A. Tungsten light.*

17. Cannonball Mozambique, 1980. The driver kept saying, "You have to see our fort." I've traveled a great deal and I've seen an awful lot of forts, and I just *hate* forts. As a matter of fact, I generally refuse to go to them. But he was really persistent. I came to the most beautiful fort I have ever seen, all whitewashed. I leaned against a pyramid of cannonballs and they moved. I couldn't believe it. In every fort I've been to, cannonballs are always welded together. I realized that I had a circular, geometric shape in a fort that was all straight-line geometry. The textures were great and it was a beautiful time of day, so I started placing cannonballs around the fort. *Nikon F, waist-level finder, 20mm Nikkor. CC50B filter. Kodachrome Type A.*

18. Doorway to Nowhere 1 India, 1963. Jai Singh Observatory, Jaipur. *Nikon F, 200mm Nikkor. Polarizing filter.*

19. Monument to the Stars 1 India, 1983. Jai Singh Observatory, Jaipur, had been on my list as one of the places I had photographed, but where I hadn't really achieved my goal. I have now gotten it out of my system. I feel that I have done as definitive a picture as I'll ever make of it. *Nikon camera, 20mm Nikkor. Polarizer plus 85B filter.*

20. Monument to the Stars 2 India, 1983. Jai Singh Observatory, Jaipur. The beauty of the 15mm is that if you keep it perfectly horizontal you get straight-line perspective. *Nikon camera, 15mm Nikkor.*

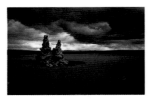 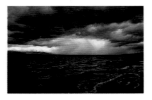 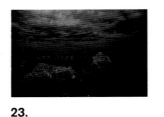 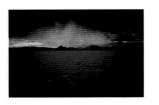 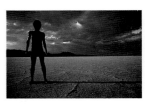

21. **22.** **23.** **24.** **25.**

21. Sand and Storm California, 1982. Mono Lake. *Nikon F2, 20mm Nikkor.*

22. Water and Storm California, 1982. I was on a trip to photograph in and around Yosemite National Park and thought I'd go on to Mono Lake because of the interesting mineral formations on its shores. As I got there, enormous gray clouds started flying by. I looked out across the lake and photographed an incredible storm coming at me from the distance. It began hailing. It was like the end of the world. After the storm went by, I started working with the formations in relation to the clouds. *Nikon F2, 20mm Nikkor.*

23. Grand Canyon Arizona, 1967. I think it's almost impossible to photograph the Grand Canyon if you try to capture the feeling of the immensity of it. It's something probably better left to three-dimensional photography of the future. *Nikon camera, 20mm Nikkor.*

24. Salt Flats Utah, 1970. While I was photographing, a storm came up and I was presented with backlit rain and a sunset. *Nikon camera, 20mm Nikkor.*

25. Man Utah, 1970. I finished a commercial assignment and asked the model if he would be willing to pose for a nude, because I felt that his skin color against the pure white of the salt flats was unique and that the light was right. I'd never done a male nude. *Nikon camera, 20mm Nikkor.*

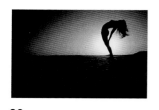

26.

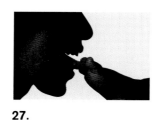

27.

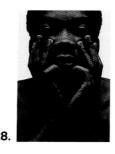

28.

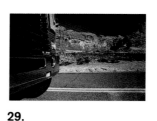

29.

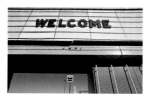

30.

26. Woman California, 1974. I had already done *Man* and was looking for the pair. I like symbols and thought, What good is a man without a woman? Working in California, I took some time off and went out to El Mirage, some mud flats near Palmdale, and photographed a nude woman in silhouette. I always saw the pictures as working together. I knew the horizon line in the first photograph and I maintained the same horizon line in the second. I like the horizon line just about halfway through a photograph. *Nikon camera, 20mm Nikkor. Wratten 16 filter.*

27. Licking New York, 1968. From a story on black beauty for *Look* magazine. I added a little bit of red to the strobe color, the equivalent of a CC10R, to warm it up a bit. I used toplight, which I find can produce beautiful shadows. *Nikon F, 105mm Nikkor.*

28. Looking New York, 1968. The man is Milton Nascimento, a wonderful composer. The picture was made for a record album cover. Toplight was also used. *Nikon F, 105mm Nikkor.*

29. Truckstop Utah, 1974. I made this picture during a lunch break on a job for International Harvester. I was looking at the truck very closely; it was surreal, a metallic, futuristic object in the ancient landscape of Arches National Park...and the yellow stripes. I picked up my camera and did some personal work. *Nikon camera, 20mm Nikkor. Polarizing filter.*

30. Welcome Arizona, 1967. I stayed at a Holiday Inn while on a trip in the West and saw this sign at night when I was checking into the hotel. I thought it looked interesting. The next day, when I drove by, it was all clean and new; it demanded to be photographed. I loved the orange, the yellow, and the blue sky. To me, it is pure Americana. *Nikon F, 20mm Nikkor.*

 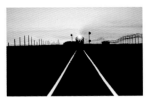 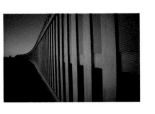 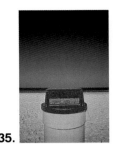

31. **Texascape** Texas, 1968. I happened to be driving by a used car lot one evening and noticed the sun setting behind it. The cars were backlit with the sun's afterglow and toplit with the light bulbs. I came to a screeching halt, ran out, and photographed this image. *Nikon F, 20mm Nikkor.*

32. **Feeling High** United States, 1970. Traveling by plane, you rarely see anything these days because you fly so high. But when you fly west into the sun the sunsets last for quite a long time. I was watching the buildup of orange color on this window, and kept looking out at the engines in a beautiful glow of sunset. I remembered that if you use a polarizing filter through the plastic window you get a rainbow effect, so I grabbed my camera as quickly as I could and made some exposures. *Nikon F, 20mm Nikkor. Polarizing filter.*

33. **Tracks** Nevada, 1980. My plan this day was to shoot perspectives. I thought of roads, and jumped to the thought of railroads. I began looking at rails running west so I could pick up the track reflection in the sunset. The camera was on a tripod as I waited for the afterglow in the moments after the sun drops below the horizon. I wasn't expecting the train. I started shooting, and kept shooting, changing the aperture, stopping down, to get the effect of the radial spread of the headlight. *Nikon F2, 200mm Nikkor.*

34. **Road Song** Kansas City, 1967. I don't know why I always get from people such an overwhelming, positive response to this image. It's gratifying, but also curious. It seems to evoke an emotion. Is it loneliness? It is a kind of song of the road, though I only show the road symbolically. Roads are like life. Transitional elements. You're always looking forward to seeing what's around the next bend. What was the reality? I had seen a running fence from the window of a taxiing plane. What was the feeling? The mood? The answer seems to be different for each viewer. Maybe there are no answers for images like this, which is subtle compared to much of my work. *Nikon F, 20mm Nikkor.*

35. **Push** Florida, 1970. I decided to take a couple of days off on the Gulf Coast and relax. I was by the pool. I looked up and happened to notice a trash receptacle, brand-new, yellow and red—primary colors. I'd never seen one like that. There was a beautiful blue sky, cloudless. I went back to my room for my camera and a 20mm lens. I positioned the can on the beach so the top was directly in line with the horizon. I used a polarizing filter to darken the sky, manipulating reality to some extent. *Nikon F, 20mm Nikkor.*

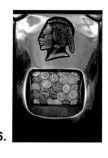 **36.**

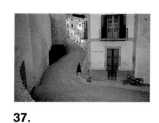 **37.**

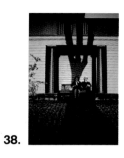 **38.**

 39.

 40.

36. The Last American Indian Utah, 1967. I liked the juxtaposition of the coins in this slot machine with the Indian's face. *Nikon F, 55mm Micro-Nikkor.*

37. Ibiza Woman Ibiza, 1961. Framing the scene in the viewfinder, I became intrigued by the image of the women all dressed in black against the whitewashed walls. I waited until a woman crossed the street. When she hit the curb with her foot, the composition felt just right. This, in a sense, is as close as I ever came to doing reportage photography. *Nikon camera, 35mm Nikkor. CC50B filter.*

38. Old Age Stockholm, 1968. I was in Sweden working on a film of Chekhov's play *The Seagull.* Walking in a park, I saw this wonderful couple, dressed as from another time. I was able to hide my shadow in the larger shadow of the tree. *Nikon F, 20mm Nikkor.*

39. Singapore Man Singapore, 1963. The man didn't want to be photographed, so I couldn't put the camera up to my eye. I hand-held this, just guessing at the framing, for a long exposure—one second. *Nikon SP (rangefinder), 50mm Nikkor.*

40. Dyer's Hand Jaipur, 1963. A man was working with red textile dye. I was excited by the color and wanted to do a close-up of his hands. I focused, and just as I did, a fly landed. I took one picture and the fly zipped off. *Nikon F, 50mm Nikkor with close-up attachment.*

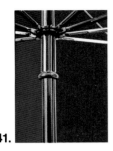

41.

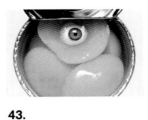

42.

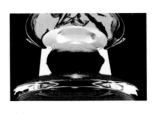

43.

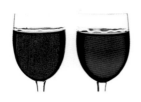

44.

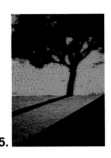

45.

41. Umbrella Victoria Falls, 1970. Umbrellas are provided for tourists at this incredible natural site in Africa because the mist from the falls can soak you. Harold Hayes was with me and said, "Here you are, Pete, in front of one of the wonders of the world, and what are you shooting? An umbrella!" I said, "But Harold, look at the reflections!" *Nikon F, 55mm Micro-Nikkor.*

42. Aperitif New York, 1966. While shooting *Chessboard* I observed that the liqueurs crept up the sides of the glasses. I decided to try different-shaped glasses and used a close-up lens to catch the effect. (See *Chessboard,* Plate 16). *Nikon F, 55mm Micro-Nikkor. Kodachrome Type A. Tungsten light.*

43. Eye to Eye New York, 1968. After I did *Soft Room* I had a lot of glass eyes left over. I tried placing one eye on different substances. I tried ketchup, a variety of canned goods, and finally peaches. There's no deep meaning to this whatever. Just an eye-catcher. *Nikon F, 55mm Micro-Nikkor.*

44. Dressings New York, 1968. Lemon, vinegar, and oil. It's a play of color. Color, and shading, and shadow. *Nikon F, 20mm Nikkor.*

45. Zimbabwe Tree Zimbabwe, 1959. Eric Meola, who was managing my studio in 1969, ten years after I made this original photograph, suggested that I might try a green filter over it. We did, and it became a strong image. *Nikon SP, 105mm Nikkor.*

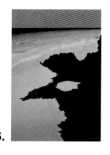 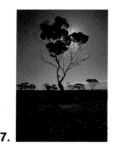 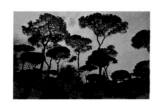 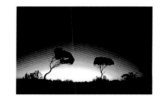 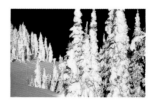

46. **47.** **48.** **49.** **50.**

46. Cancun Bird Cancun, 1981. I was walking on the beach when I saw a rock creating a birdlike shadow. It's fun to see objects in the shadows of other objects. *Nikon F2, 20mm Nikkor.*

47. Nullarbor Trees 1 Nullarbor, 1985. I was in Australia and decided to drive along the south coast, where there is a line of high cliffs and the land is desertlike. Beyond this point there are no more trees for over a thousand kilometers. *Nikon F2, 20mm Nikkor.*

48. Umbrella Trees Rome, 1962. This is a double exposure of pine trees just outside Rome on the road to Ostia. *Nikon SP (rangefinder), 28mm Nikkor.*

49. Nullarbor Trees 2 Nullarbor, 1985. The afterglow of sunsets is a curious phenomenon. I never noticed that purplish-reddish color twenty years ago, although I now see it in other photographers' work. I don't know if the effect is caused by something happening in the atmosphere, or if we're learning to shoot much later into the evening than we ever did, or if films are reacting differently. Maybe, years ago, after the sun went down, we packed up and left too soon. Now I keep going for another thirty minutes. *Nikon F2, 20mm Nikkor.*

50. Winter Trees Montana, 1961. This was done at a high altitude with a polarizing filter that I used to blacken the sky. The effect is further heightened by the optical printer, which raises the contrast of the image. *Nikon F, 105mm Nikkor.*

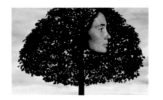 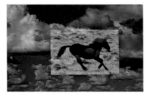 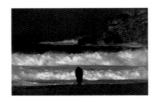 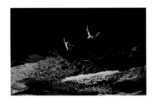 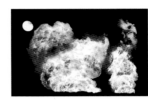

51. **52.** **53.** **54.** **55.**

51. Daydreams of Magritte 2 Stockholm, 1968. The film was double exposed in the camera. First I photographed the tree. Actress Kathleen Widdoes was photographed in front of a black background. I used a Nikon "E" finder screen, because its etched vertical and horizontal lines allowed me to position the elements precisely for the second exposure. *Nikon F, 105mm Nikkor.*

52. Horse in Clouds Nevada, 1971. A rectangle within a rectangle. It has the surreal quality I wanted. The horse has good motion. I've always liked the horse alone, but combining it with clouds seemed like a natural thing. Many times I don't previsualize, I postvisualize. *Nikon camera, 200mm Nikkor (mustang), 105mm Nikkor (clouds). Optically assembled.*

53. The Old Man and the Sea Nazaré, Portugal, 1966. You don't make an image like this. You don't make a day with an incredible storm, graphic waves. I just managed to take a few frames before the man walked away. *Nikon F, 105mm Nikkor.*

54. Flying Women Dominica, 1976. Composed and orchestrated on location specifically for this result. Viewing the photograph upside down, as it is reproduced here, makes the women seem to fly. It almost looks like a space scene. If you turn the picture around, you can see that it's still strong, but it's an entirely different feeling. *Nikon F2, 20mm Nikkor.*

55. The Phoenix Libya, 1964. If you look to the right, you'll see a birdlike face. You've heard of the firebird rising from the flames? In itself, photographing the flames would not have been enough unless I was able to capture something else; it wouldn't have had any content for me. The moon was exposed on the same frame later that evening. *Nikon F, 200mm Nikkor.*

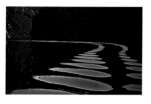 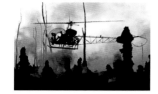 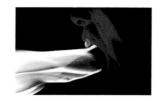 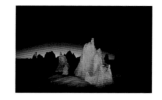 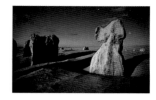

56. **57.** **58.** **59.** **60.**

56. Boat Wake Norway, 1966. This is almost a visual recording of the vibrations of the engine. *Nikon F, 105mm Nikkor. CC50B filter.*

57. Descent Hawaii, 1967. I was there to photograph the volcano. I'd asked the pilot of the helicopter to drop me off. As he began to lift away, I realized that a very interesting image was created by the strange, insectlike machine in the midst of this hellish environment. I motioned for the pilot to hover. I was sinking into the hot pumice; it wasn't much fun. *Nikon F, 105mm Nikkor.*

58. Fire-eater Hong Kong, 1967. He was a professional fire-eater, but I remember that I asked him to hold the pose too long. He was so angry, his teeth were practically cracking in his mouth. I never saw anything like it; his lips were smoking. *Nikon camera, 55mm Micro-Nikkor.*

59. Pinnacles 2 Pinnacles Desert, 1985. This is a small area north of Perth, Australia; it looks like another planet. That's what attracted me to the place. I used an 85B filter over my Nikon SB 16 strobe to warm the image and show detail. By filtering the strobe, I was able to capture the afterglow in its unfiltered colors. *Nikon F3, 20mm Nikkor.*

60. Pinnacles 1 Pinnacles Desert, 1985. *Nikon F3, 20mm Nikkor.*

 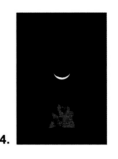 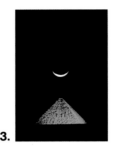 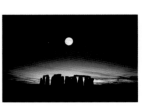

61. **62.** **63.** **64.** **65.**

61. Nazaré Nazaré, 1966. For me there is an interesting relationship between the backgrounds of this rainbow in Portugal and the scene in Iceland in plate 62. They're different, and yet so similar: there are dark walls behind both. When I went to Portugal, I was expecting blue skies. I never imagined Nazaré as a stormy or cloudy place. But when a wonderful storm came up, with black skies and a rainbow, I had to pick up my camera and record it. *Nikon F, 200mm Nikkor.*

62. Black Snow Heimaey, 1973. This is a village inundated by volcanic ash. I knew there had been a volcanic eruption in Iceland and I made a point to be there. In this sense I'm *making* pictures, not just *finding* them, as I had done with the rainbow in Portugal. It was no accident that I was in Iceland at this time. *Nikon F, 200mm Nikkor.*

63. Pyramid
64. Sphinx Cairo, 1964. These were meant to work as a pair. The idea came from Allan Porter, an editor for *Holiday* magazine at the time. He had assigned me to do a story on Egypt. He reminded me that there was an eye over the pyramid on the dollar bill, but suggested that no one had put a moon over a pyramid. After seeing crescent moon shapes on various buildings and churches in Egypt, I decided to wait for the crescent moon's precise one-eighth circle shape. Again I used the etched finder screen for exact subject placement. I carried Allan's idea a bit further by also shooting the Sphinx. The colors on both monuments are from the lights projected at night during a sound and light show for tourists. *Nikon F, 200mm Nikkor.*

65. Stonehenge Stonehenge, 1979. I deliberately arrived during full moon. The day was unbelievably gorgeous and I got one of those afterglows that you dream about. Then I looked behind me and saw that the moon was rising. I waited a few more hours until it was well above the horizon. *Nikon F2 (with "E" screen), 20mm Nikkor (Stonehenge), 105mm Nikkor (moon).*

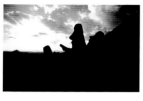 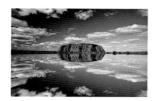 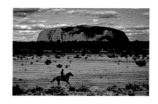 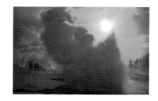 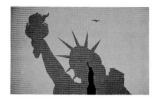

66. **67.** **68.** **69.** **70.**

66. Easter Island Easter Island, 1982. One of the exciting things about working in a natural environment is that the earth, the clouds, the light, the elements are always changing. *Nikon F2, 35mm Nikkor.*

67. Ayers Rock 1 Uluru National Park, 1983. I looked at this Australian natural wonder from the air; I shot it from the ground. I shot it at predawn, sunrise, sunset, afterglow. And I came to realize this is the best angle to view it from. I had been impressed with photographs I'd seen of the rock reflected in pools of water. I created my version—a perfect mirror image flopped and combined in the optical printer. *Nikon F2, 20mm Nikkor. Polarizing filter.*

68. Ayers Rock 2 Uluru National Park, 1983. The cowboy aborigine was photographed about 200 kilometers away from the rock. This combination was the idea of my former studio manager Lee McElfresh. (Note the soft focus in midground.) *Nikon F2, 105mm Nikkor. Optically assembled.*

69. Old Faithful Yellowstone National Park, 1961. A familiar geyser photographed at an unusual time of year, winter. A blue filter gave me the cold mood. *Nikon F, 105mm Nikkor.*

70. Liberty New York, 1962. Double exposed in the camera. I went to the Battery and shot with a long lens for the small image. Then I took the boat to Liberty Island and kept shooting as we got closer and closer. The airplane flying by was just luck. *Nikon F, 200mm Nikkor.*

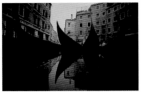

71.

72.

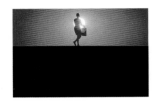

73.

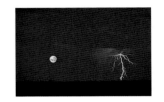

74.

75.

71. Venice Venice, 1972. The magic of a floating city. I boated around Venice the first time I was there, though I actually liked walking better. I found this natural reflection in a canal, but the day was overcast and the photograph needed something. I felt that it would look great if it were like gold at the end of the day. *Nikon F, 20mm Nikkor. 85B filter.*

72. Portugal Reflection Portugal, 1966. I got out of my car to photograph the red door on the white house, and, as I looked over the roof of the car, I found this fascinating reflection. So I spent some time cleaning the top of the car; the curvature gives a slightly distorted image. *Nikon F, 20mm Nikkor.*

73. Shopping Cartagena, 1971. The day before I made this photograph I had seen the bridge without a railing at sunset. The sun dropped right behind it and made a black silhouette. Nothing destroyed the graphic integrity; the bridge was perfectly flat. Next day I was able to find the right angle and waited for a passerby to cross over. *Nikon F, 200mm Nikkor. 85B filter.*

74. Lightning Nullarbor, 1984. Driving east at dusk in South Australia, I saw the lightning start to flash, quickly stopped, set the camera on a tripod, opened the lens, and used a time exposure. Strictly a matter of hope. I needed at least a four-minute exposure to record the blue of the sky. Because of the brevity of the lightning and the length of the exposures I only got one frame. The moon was added later. *Nikon F2, 20mm Nikkor.*

75. Sand Egypt, 1964. Light plays on texture. I can get involved in photographing this kind of thing forever. *Nikon F, 105mm Nikkor.*

 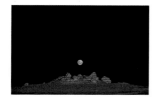 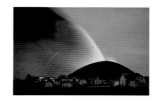 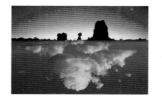 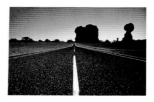

76. **77.** **78.** **79.** **80.**

76. Snow Montana, 1961. Although this was photographed half a planet away, the quality of this image is much like that of *Sand*. Beautiful texture. *Nikon camera, 105mm Nikkor.*

77. Moon's Moon 3 Libyan Desert, 1964. Oil field burn-off lit up a mountain of sand. *Nikon F, 200mm Nikkor.*

78. New Dawn Heimaey, 1973. That a volcano was erupting in the middle of a small town was the concept that excited me. Volcanoes erupt all the time, but in a town? A long exposure, about 30 seconds, is what gave the image its softness, that silky beauty in something that is inherently cataclysmic. *Nikon F, 35mm Nikkor.*

79. Shapes of Clouds to Come
80. Shapes of Roads to Come Arches National Park, 1971. These pictures were done as separate elements with the idea of combining them later. The top halves were some interesting rock formations, about four feet high, that I found in the park. Combination with the road gives them a gigantic feeling, but they're not that large. There was an incredibly clear afterglow behind the rocks. These kinds of images lend themselves to multiples. They contain keys to worlds of the imagination. *Nikon camera; for no. 79, both elements 105mm Nikkor; for no. 80, 20mm Nikkor (roads), 200mm Nikkor (rock formations). Optically assembled.*

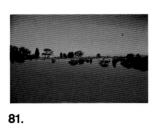
81.

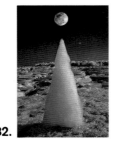
82.

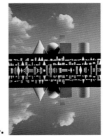
83.

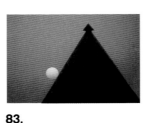
84.

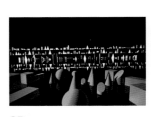
85.

81. Wainscott Wainscott, Long Island, 1973. I had never tried a "reflection" photograph in which the image was reversed, and then combined, as if in a mirror. I have a natural tendency to make shapes symmetrical, top and bottom, so I wanted to see what would happen if I broke that rule. The use of a hot gold at the top, with a purple at the bottom, gives the picture more gravitational weight. If you turn it upside down, it won't feel right. *Nikon F2, 35mm Perspective–Control Nikkor.*

82. Antarctica New York, 1980. This was actually photographed out on Long Island. I'm always playing with geometry and nature. *Nikon F, 20mm Nikkor.*

83. Rolling Ball Sudan, 1959. This is the first photograph in which I learned to play with geometry. I'm using the sun and the top of an African railroad station hut to experiment with the relationship between a circle and a triangle. This image was a turning point for me. *Nikon SP, 105mm Nikkor. Wratten 21 filter.*

84. Shapes of Things to Come 1 Fire Island, 1969. Here I was getting into complex reflections and combinations of elements. If you were to take out the middle elements—all the small shapes—and then compress the sides, you could make another image. But I felt the need for complexity. The result looks like a futuristic city to me. *Nikon F, 20mm Nikkor. Optically assembled.*

85. Shapes of Things to Come 2 New York, 1970. Using the same elements as in plate 84, I was working with perspective instead of reflections. *Nikon F2, 20mm Nikkor.*

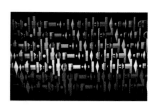 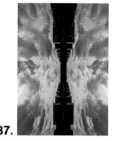 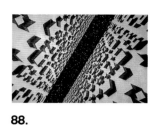 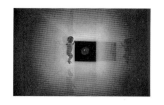 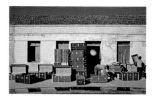

86. **87.** **88.** **89.** **90.**

86. Progressive Geometric Shapes New York, 1970. A technically complex image, which on another level is very simple—geometry and the spectrum. My later work becomes more complex technically, but it is directed to achieving simpler goals. All exposures in-camera. *Nikon F2, 28mm Perspective–Control Nikkor.*

87. Future City Brasília, 1981. I see a sky city. Ever since I was a kid I've read science fiction; it is a great escape, but also great visual fantasy. *Nikon F2, 15mm Nikkor. Optically assembled.*

88. Brasília Walls Brasília, 1981. Brasília is a relatively new city. The buildings are arranged in a strict, rectilinear order. When I found this geometric pattern on one building, I used it to create an image of an ultimate city. *Nikon F2, 15mm Nikkor. Optically assembled.*

89. Baby in the Cube New York, 1974. The world of the imagination. Take the idea of photographing a baby: placing a sphere in back of the baby drops the image out of reality. You're in a different world. *Nikon camera, 20mm Nikkor. Optically assembled.*

90. Doorway and the Sphere Portugal, 1966. An event of mind is taking place. This picture is rather simple, only two elements. I looked at that doorway as a pure geometric space, a black rectangle. What fits better with a rectangle than a sphere? I held this photograph twelve years until, in 1978, it came together—a way to make the image more important than it was. *Nikon camera, 20mm Nikkor. Optically assembled.*

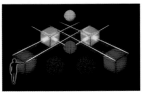 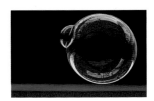 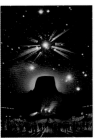 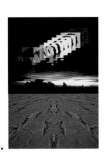 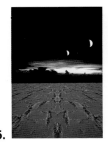

91. **92.** **93.** **94.** **95.**

91. Pixelated Geometrics New York, 1985. I wanted to create the effect of pixels (dots of resolution on computer monitors) with real models. I built three-dimensional shapes a foot high and photographed them through different gels. *Nikon F3, 105mm Micro-Nikkor. Final image optically assembled.*

92. Bubble and Stripes New York, 1980. Bubbles are fascinating. Scientists think of them as minimal structures. As a bubble deteriorates, its surface tension shifts to create beautiful patterns. All I've done is to enhance the patterns by photographing the bubble inside a chamber lighted with spectrum colors. *Nikon F2, 105mm Micro-Nikkor.*

93. Close Encounters of the Third Kind New York/Los Angeles, 1977. I created the poster for the Steven Spielberg motion picture, with great suggestions from Doug Trumbull. *Nikon F2, Nikkor lenses. Optically assembled.*

94. Plains and Progressive Man New York, 1981. This is from a series of four images that I call *The Plains of Forever.* I used various location photographs plus studio elements to create imaginary places. You sit down, and at the horizon an event takes place—any event in your mind, such as a planet you can go to anywhere in the universe. Here, I also wanted to create an evolutionary feeling. *Nikon F2, 20mm Nikkor. 35mm Perspective–Control Nikkor. Optically assembled.*

95. Plains and Spheres New York, 1981. In my mind, this is another world, in a sense a dreamscape. The *Plains* series allows my imagination to wander, to create new worlds. *Nikon F2, 20mm Nikkor, 55mm Micro-Nikkor. Optically assembled.*

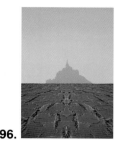 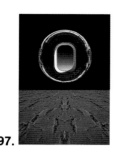 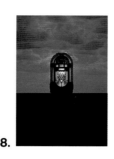 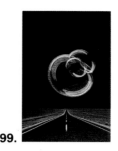 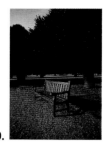

96. **97.** **98.** **99.** **100.**

96. Plains and Mont St. Michel New York, 1981. One of my personal Wonders of the World. I've always wanted to take that distinctive shape out of its present reality. Here, the *Plains* blue works with a usually difficult green. It's there on a horizon your eye accepts but your mind can only wonder at. *Nikon camera, 20mm Nikkor, 200mm Nikkor. Optically assembled.*

97. Plains and Window New York, 1981. The doorway to the *Plains* does not lead to a final destination. The *Plains* lie beyond our reality. And beyond that? Another reality, another window into another world. Imagination is not finite. Its dimensions are beyond measure. *Nikon F2, 20mm Nikkor, 105mm Micro-Nikkor. Optically assembled.*

98. Jukebox Los Angeles, 1982. This is a game I play quite often. What happens when you take an object out of its usual environment? Shot at dusk on an asphalt surface, this is a single image, not a multiple. The jukebox is powered from a portable generator. Isolated on the clean, black horizon, the subject is freed from the crush of its everyday reality. *Nikon F2, 85mm Nikkor.*

99. Future Road Nevada/New York, 1981. This is a variation of the *Plains* series. I began to think of a fantastic, jewellike object floating above me. Is this road the first stage on a visual journey? *Nikon camera, 20mm Nikkor, 105mm Micro-Nikkor. Optically assembled.*

100. Benchmark London, Hampton Court, 1979. A place to sit and think about Time. Time Present, Past, and Future. The photographs in this book deal with alternate realities. The bench is real, but possibilities abound.

ACKNOWLEDGMENTS

I would like to sincerely thank many people for helping to make this book of my personal work a reality.

Special appreciation goes to Sam Antupit, Bob Morton, Harriet Whelchel, and Shun'ichi Yamamoto at Harry N. Abrams, and to Jack Abrams, Richard LoPinto, and Sam Garcia at Nikon. I am grateful also to Richard Barkle and Pan American World Airways.

My current studio staff, consisting of Rob Atkins, Phyllis Giarnese, John Harcourt, and Francesco Ruggeri, worked diligently with me to produce the book.

I also wish to thank the following people who have been associated with my studio over the years: Lane Berkwit, Roberto Brosan, Chris Collins, Anthony Edgeworth, Ted Kaufman, Jack Kenner, Dick Kransler, Steve Krongard, Hank Margeson, Lee McElfresh, Eric Meola, Bob Monkton, Jay Nadelson, Jeff Perkell, Randy Phillips, Jake Rajs, Bob Stern, Michel Tcherevkoff, Gasper Tringale, John Turner, and Sam Varnado.

In addition, my appreciation goes to the following individuals who have contributed in various ways to this monograph: Robert Bagby, Miles Barth, Mary Kay Bauman, Elizabeth Biondi, Arthur Brackman, Henrietta Brackman, Russ Branscom, Dale Brown, Bob Ciano, Margo Crabtree, Candy Creed, Gunther Deichmann, Frank DeVino, John Durniak, Marty Forscher, Larry Fried, Ira Friedlander, James Garcia, Bill Gott, Ernst Haas, Peter Hirsch, Will Hopkins, Harvey Kahn, Stanley Kanney, Peter Lacey, Joe LaRosa, Sidney Lumet, Barry McGlone, Louis Mercier, Greg Morrison, Margaret Myers, Gene O'Rourke, Julia Phillips, Jack Piccolo, Annette Ponsford, Allan Porter, Judith Shepherd, Steven Spielberg, Carl Stewart, Adrian Taylor, Creed Taylor, Faith Terry, Pat Terry, Kanta Thakur, Boris Tisminiezky, Douglas Trumbull, Mike Valenti, Eelco Wolf, and Frank Zachary.

CHRONOLOGY

1934 Born May 30 in Albany, New York. Only child of parents Donald and Ruth. Father was well-known bandleader.

1945 Moves to Rochester, New York. Through a friend is introduced to photography; makes his first pictures.

1948 Begins to experiment with the processing of color-print and transparency material.

1952 Enters the Rochester Institute of Technology, majoring in photography and art. Studies under Ralph Hattersley.

1956 Graduates from RIT with a Bachelor of Fine Arts degree. Among graduating class are Bruce Davidson, Paul Caponigro, Carl Chiarenza, Peter Bunnell, Ken Josephson, and Jerry Uelsmann.

1957 Commences military service with Second Signal Corps in Long Island City, New York. Experiments widely with color materials while operating a photographic lab for the military.

1958 Moves to New York City after discharge from military. Does first major published work, photographs of Barnum and Bailey's circus, which appear in *Look* magazine in 1961.

1959 First major assignment, commissioned by Airstream Trailer Company. Travels for six months from Capetown to Cairo. Photographs published in *National Geographic* and *Horizon* magazines.

1961 *Esquire* publishes photo essay on railroads in America, which marks the beginning of a long friendship between Turner and editor Harold Hayes.

1962 Begins major advertising work. Editorial photography appears regularly in *Esquire, Holiday, Twen* (Germany), and *Sports Illustrated.*

1964 Receives Outstanding Alumnus Merit Award from Rochester Institute of Technology. Returns to Africa.

1965 Marries Reine Angeli. Named one of the outstanding young men of America by the Junior Chamber of Commerce, New York. Named in *Who's Who in America.*

1966 Opens first studio at 300 East 33rd Street. Shifts his main emphasis from editorial to advertising photography, while pursuing personal work. Turner's images increasingly reflect the surreal. He begins to explore the manipulation of reality through photography.

1968 Moves studio to Carnegie Hall building.

1969 Son, Alexander, is born.

1970 Travels to Africa with Harold Hayes, who suggests the "God's Ears" project.

1971 *Esquire* publishes "God's Ears," personal photographs of Maasai tribesmen.

1972 Receives Award of Special Merit from the Art Directors Club of New York.

1973 Photographs volcanic eruption in Heimaey, Iceland.

1975 Photographs Moscow for the Time-Life Books series The Great Cities.

1976 One-man show, *Time Space in Color: A Retrospective,* designed with Will Hopkins, at the Minneapolis College of Art and Design. Show later travels to Paris.

1977 Opens the Space Gallery at Carnegie Hall in an effort to promote color photography as fine art and to present the work of contemporary color photographers. Photographers Jay Maisel and Ernst Haas are partners in the gallery. Reine Turner is curator.

1978 Works closely with Douglas Trumbull and Steven Spielberg on special effects stills for the movie *Close Encounters of the Third Kind.*

1979 Conducts Color Dynamics workshop in Venice under the auspices of UNESCO and the International Center of Photography, New York.

1981 Receives the Outstanding Achievement in Photography award from the American Society of Magazine Photographers.

1982 Subject of a cover story in *American Photographer* magazine. Hosts *The Photographer's Eye,* a twenty-nine—episode television series sponsored by Nikon, Inc., in which Turner converses with other top photographers.

1986 Has now received more than 250 awards from the Art Directors Club of New York, including numerous gold and silver Awards of Excellence.

GROUP SHOWS

1961 *Photography in the Fine Arts.* The Metropolitan Museum of Art, New York

1963 *Mostra Biennale Internazionale della Fotografia.* Venice

1963 *Photography in the Fine Arts IV.* The Metropolitan Museum of Art, New York

1964 *ASMP, An Exhibition of Significant Photography.* Jacksonville Art Museum

1965 *Photography '65 International.* International Museum of Photography at George Eastman House, Rochester, New York

1967 *Photography in the Fine Arts V.* The Metropolitan Museum of Art, New York

1967 *Photography in the Twentieth Century.* National Gallery of Canada, Ottawa

1967 *Man in Sport.* The Baltimore Museum of Art

1970 *ASMP, Best of Twenty-Five Years.* New York Cultural Center

1970 *The Photograph as a Permanent Color Print.* New York Cultural Center

1972 *Alexey Brodovitch and His Influence.* Philadelphia College of Art

1974 *The Eye of the Beholder.* Squibb Gallery, Princeton, New Jersey

1974 *International Center of Photography Inaugural Exhibition.* New York

1974 *Photography U.S.A.* Bucharest International Fair

1975 New York Cultural Center

1975 *In Just Seconds.* International Center of Photography, New York

1975 Clarence Kennedy Gallery, Boston

1975 *The Art of Color.* International Center of Photography, New York

1976 *Parallax: Perspectives on Photography.* Massachusetts Institute of Technology, Cambridge

1978 Kimbell Art Museum, Fort Worth

1979 *Photographic Surrealism.* New Gallery of Contemporary Art, Cleveland

1979 Venezia la Fotografia. Venice

1980 *International Photographic Event.* Satakunta Museum, Pori, Finland

1984 *The Image Bank: An Intimate Look.* Neikrug Gallery, New York

1984 *The Professional Photographer's Showcase.* Epcot Center, Lake Buena Vista, Florida

1984 *ASMP, Fortieth Anniversary Exhibition for Photokina.* Opened Photokina, Cologne, West Germany, followed by worldwide tour

1985 *Personal Best.* Daytona Beach Community College

ONE-MAN SHOWS

1968 International Museum of Photography at George Eastman House, Rochester, New York. Six editions of this exhibition of forty-three prints subsequently traveled to fifty-two countries on all continents through 1971. First European venue, Photokina, Cologne, West Germany

1969 The Photographers Gallery, New York

1976 *Time Space in Color: A Retrospective.* Minneapolis College of Art and Design

1976 *Time Space in Color: A Retrospective.* Galerie Nikon, Paris

1977 *Jazz Landscapes.* Thumb Gallery, London

1977 Realisiarte Impressionen, Zurich

1978 The Space Gallery, New York

1979 Boris Gallery of Photography, Boston

PERMANENT COLLECTIONS

1960 International Museum of Photography at George Eastman House, Rochester, New York

1984 The Metropolitan Museum of Art, New York

1986 International Center of Photography, New York

BIBLIOGRAPHY

Monographs

Campbell, Bryn, ed. *I Grandi Fotografi, Pete Turner.* Milan: Gruppo Editoriale Fabbri, 1982. Rev. French ed. *Les Grands Maîtres de la Photo, Pete Turner.* Paris: Editions Filipacchi, 1983. Rev. U.S. ed. *The Great Photographers, Pete Turner.* English text by Myrna Masucci. Englewood Cliffs, New Jersey: Prentice-Hall, 1984.

Works Included in the Following Publications

Brackman, Henrietta. *The Perfect Portfolio.* New York: Amphoto, 1984.

Capa, Cornell, ed. *International Center of Photography Encyclopedia of Photography.* New York: Crown Publishers, 1984.

Coleman, A. D. *Lee/Model/Parks/Samaras/Turner.* Boston: Photographic Resource Center, 1979.

Color. Life Library of Photography. Alexandria, Va.: Time-Life Books, 1970. Rev. ed., 1981.

Frontiers of Photography. Life Library of Photography. Alexandria, Va.: Time-Life Books, 1972.

Gambaccini, Peter. *Getting to the Top in Photography.* New York: Amphoto, 1984.

Gruen, Al. *Contact Sheet: The Secret of Creative Photography.* New York: Amphoto, 1982.

Gruliow, Leo. *Moscow.* The Great Cities. Alexandria, Va.: Time-Life Books, 1977.

"Inferno on an Island." *Photography Year 1974.* Alexandria, Va.: Time-Life Books, 1975.

Lacey, Peter. *Nude Photography.* New York: Amphoto, 1985.

Lyons, Nathan. *Photography in the Twentieth Century.* New York: Horizon Press, 1967.

Mexico. Alexandria, Va.: Time-Life Books, 1967.

The Nikon Image. Long Island City, N.Y.: Ehrenreich Photo-Optical Industries, Inc., 1975.

O'Connor, Michael, ed. *The Image Bank: Visual Ideas for the Creative Color Photographer.* New York: Amphoto, 1983.

Studio. Life Library of Photography. Rev. ed. Alexandria, Va.: Time-Life Books, 1982.

Travel Photography. Life Library of Photography. Alexandria, Va.: Time-Life Books, 1972. Rev. ed., 1982.

Selected Magazine Features

April 1959	Caufield, Patricia. "Pete Turner in Negative Color." *Modern Photography.*
August 1959	Durniak, John. *Popular Photography.*
November 1960	"A Brilliance in the Bush." *Horizon.*
December 1961	"Pavane for the Iron Horse." *Esquire.*
April/May 1962	Brackman, Henrietta. "Pete Turner's World of Color." *Camera 35.*
July 1962	"Ibiza, Spain." *Esquire.*
May 1963	Durniak, John. "Focus on Pete Turner." *Popular Photography.*
August 1963	"Pacific/Orient '63." *Esquire.*
1964	"Across Eternal Egypt." *Holiday.*
July 1964	Hattersley, Ralph. "Hattersley Comments on *Rolling Ball.*" *Popular Photography.*
April 1965	Ponte, Lisa. "Fotografi di Pete Turner." *Domus* (Italy).
May 1965	Hosoya, Gan. "Pete Turner." *Mainichi* (Japan).
June 1965	"Athens." *Holiday.*
January 1966	Porter, Allan. "Pete Turner." *Camera* (Switzerland).
February 1966	"Carnival in Rio." *Holiday.*
November 1966	Karlen, Arno. *Scandinavia Holiday.*
February 1967	Joseph, Richard. "If This Should Be My Last Trip to Europe." *Esquire.*
March 1967	"Immense Journey of Loren Eiseley." *Esquire.*
March 1967	Kinzer, Mike. "Pete Turner Right Now." *Popular Photography.*
August 1967	"Step Right Up Folks, to Thirty Million Square Miles of the Greatest Show on Earth." *Esquire.*
March 1968	Porter, Allan. "Pete Turner." *Camera* (Germany).
August 1968	"Pacific Travel for the Man Who Has Been Everywhere." *Esquire.*
January 1969	"Black Beauty." *Look.*
June 1969	"Pour lui la couleur est un choc, Pete Turner." *Photo* (France).
March 1970	"La quête des couleurs sauvages, Pete Turner." *Photo* (France).
March 1970	"Warum Schwartz so aufregt." *Twen* (Germany).
July 1970	"Maasai." *Essence.*
September 1970	"Mozambique, Dream Places of the '70s." *Holiday.*
January 1971	Hedgepeth, William. "The Mark of Man." *Look.*
June 1971	"God's Ears." *Esquire.*
October 1971	*Commercial Photo* (Japan).
April 1972	"Un super galerie couleur, Pete Turner." Part I. *Photo* (France).
May 1972	"Un super galerie couleur, Pete Turner." Part II. *Photo* (France).
June/July 1972	*Foto* (Sweden).
September 1972	*Foto* (Germany).
June 1973	"The Aesthetics of Destruction." *Esquire.*
1973	*Modern Photography Annual.*
July 1973	"Pete Turner en couleur." *Photo* (France).
Summer 1973	*Photo World.*
March/April 1976	*Communications Arts.*
September 1976	*Photo* (France).
October 1976	*Photo* (France).
October/November 1976	*Photo World.*
December 1976	*Camera 35.*
January/February 1977	*Zoom* (France).
March 1977	*Photographie* (Germany).
August 1978	*Camera 35 Photo World.*
October 1979	*Fotomagazin* (Germany).
December 1979	*Il Fotografo* (Italy).
June 1980	*Il Fotografo* (Italy).
November 1980	*American Photographer.*
March 1981	"Plains of Forever." *OMNI.*
August 1981	"ICP Issue." *Nikon World.*
January 1982	Durantes, Sergio. "Earth, Wind, and Fire—In Color." *Camera* (United Kingdom).
1982	*Nikon World Annual* (Japan).
October 1982	Bowser, Hal. "The Lost Tribes of Easter Island." *Science Digest.*
October 1982	Shames, Laurence. "Pete Turner." *American Photographer.*
April/May 1983	*Camera Craft* (Australia).
June 1983	*American Photographer.*
March 1984	Ward, Geoffrey C. "India, Ghost City of Victory." *GEO.*
June 1984	McCullough, Colleen. "Ayers Rock." *GEO.*
October 1984	Stein, Kathleen. "Plasma under Glass." *OMNI.*
December 1984	Ward, Geoffrey C. "Jaipur, India." *GEO.*
December 1984	*Zoom* (France).
August 1985	Yulsman, T. "Australia's Pinnacles Desert." *Science Digest.*
September 1985	Davies, Owen. "Skyshrine." *OMNI.*
December 1985	Bultman, J. "An Interview with Pete Turner." *Darkroom Photography.*